The Royal Horticultural Society

TREASURY *of* FLOWERS

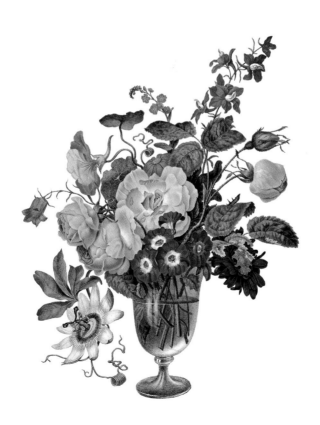

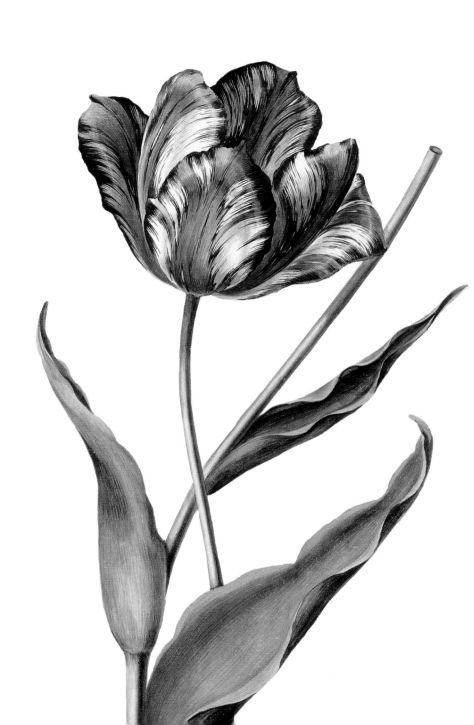

The Royal Horticultural Society

TREASURY *of* FLOWERS

Writers and Artists in the Garden

Selected by Charles Elliott

With illustrations from the
Royal Horticultural Society's Lindley Library

FRANCES LINCOLN LIMITED
PUBLISHERS

Frances Lincoln Limited
4 Torriano Mews
Torriano Avenue
London NW5 2RZ
www.franceslincoln.com

The Royal Horticultural Society Treasury of Flowers
Copyright © Frances Lincoln Limited 2006

Text selected by Charles Elliott

Illustrations copyright © the Royal Horticultural Society 2006
and printed under licence granted by the Royal Horticultural
Society, Registered Charity number 222879.
Profits from the sale of this book are an important contribution
to the funds raised by the Royal Horticultural Society.

British Library cataloguing-in-publication data
A catalogue record for this book is available from
the British Library

ISBN 10: 0-7112-2699-7
ISBN 13: 978-0-7112-2699-9

Printed in Hong Kong

3 5 7 9 8 6 4 2

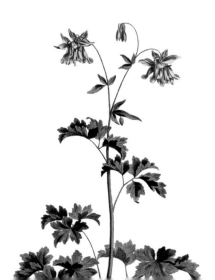

CONTENTS

INTRODUCTION

Writers seem always to have had some sort of connection with flowers, if only to help convey their own states of mind, and literature from the time of Solomon (if not before) is studded with references to particular plants. Some species have always been special favourites – it's not long since no self-respecting poet could avoid tossing into his verse mention of a rose or a lily, generally in reference to an attractive or yearned-for damsel.

Formulaic usage aside, however, it is clear that many of our finest writers were honestly and deeply moved by flowers, and regarded them as a precious part of their mental world. When Shakespeare speaks of the way daffodils 'take The winds of March with beauty' or Chaucer says of the daisy that 'Of al the floures in the mede, Thanne love I most thise floures white and rede,' their words are obviously not mere bits of poetic apparatus. The flowers have touched the poet and he is able in turn to touch us through them.

Until relatively recently, of course, most writers did not consider flowers closely and with precision. Symbols were easier to manipulate than stamens, the author's emotions more important to him than the shape of an umbel. But there was one category of writing, not strictly speaking 'literary' at all, that combined detailed observation with fresh and exciting language. This was the work of plantsman-herbalists like John Gerard and John Parkinson, men fascinated by growing things, especially in terms of their medical application. John Milton, as a classicist inescapably aware that its name meant 'unfading', could praise the 'immortal' amaranth without betraying any interest at all in its drooping crimson panicles; Gerard, on the other hand, gets right

to the heart of violet-ness, Parkinson to the essence of an anemone, the real thing, while Sir Thomas Hanmer expresses his delight in the 'great diversity' of hyacinths. These men were gardeners; they looked at their plants before writing about them.

And so did the rural poet John Clare, though his plants tended to be wild rather than garden varieties. Like Robert Burns, another countryman with a keen eye, Clare brought new eloquence to writing about nature. Direct and seemingly unsophisticated, his verses on individual species – lily of the valley, primrose, and many others – are botanically precise yet somehow deeply and even painfully human, spoken in the voice of man whose world was dying around him. The combination is extraordinary, and probably unmatched.

Moving closer to our own times, once the shoal of Victorian sentimentalists has been safely crossed the choice of writers about flowers grows broad indeed. There are the essayists like Canon Ellacombe and E.A. Bowles, whose subject is their own garden and its much-loved contents; nature writers like Henry Williamson, W.H. Hudson and John Burroughs; great horticulturalists like Gertrude Jekyll, Reginald Farrer, Margery Fish and others, whose writings not only teach but inspire; and poets capable of engaging with flowers so intimately that it shakes you. In the latter category must be Theodore Roethke's poem on orchids, Anne Stevenson writing about Himalayan balsam and above all D.H. Lawrence's 'Bavarian Gentians.' The only problem for the anthologist is where to stop. The garden goes on and on.

Charles Elliott

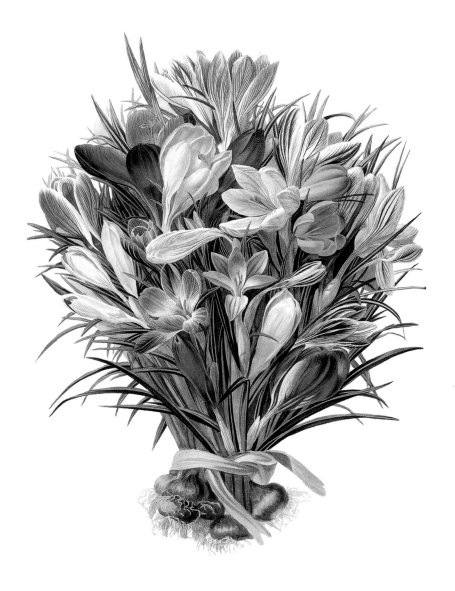

CROCUS

See the crocus' golden cup
Like a warrior leaping up
At the summons of the spring,
'Guard turn out!' for welcoming
Of the new elected year.
The blackbird now with psalter clear
Sings the ritual of the day
And the lark with bugle gay
Blow reveille to the morn,
Earth and heaven's latest born.

Joseph Mary Plunkett, 'See the Crocus' Golden Cup' (1916)

QUEEN ANNE'S LACE

Her body is not so white as
anemone petals nor so smooth – nor
so remote a thing. It is a field
of the wild carrot taking
the field by force; the grass
does not raise above it.
Here is no question of whiteness,
white as can be, with a purple mole
at the center of each flower.
Each flower is a hand's span
of her whiteness. Wherever
his hand has lain there is
a tiny purple blossom under his touch
to which the fibres of her being
stem one by one, each to its end,
until the whole field is a
white desire, empty, a single stem,
a cluster, flower by flower,
a pious wish to whiteness gone over –
or nothing.

William Carlos Williams, 'Queen Anne's Lace' (1921)

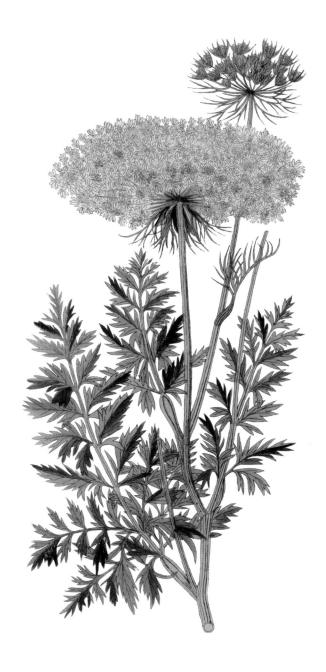

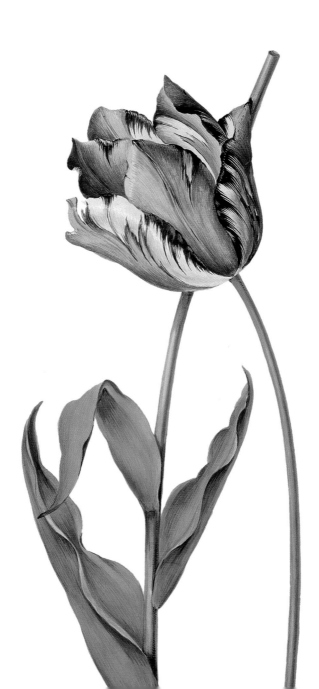

TULIP

I was very much pleased and astonished at the glorious
show of these gay vegetables, that arose in great profusion
on all the banks about us. Sometimes I considered them
with the eye of an ordinary spectator, as so many
beautiful objects varnished over with a natural gloss, and
stained with such a variety of colour, as are not to be
equalled in any artificial dyes or tinctures. Sometimes I
considered every leaf as an elaborate piece of tissue, in
which the threads and fibres were woven together into
different configurations which gave a different colouring
to the light as it glanced on the several parts of the
surface. Sometimes I considered the whole bed of tulips,
according to the notion of the greatest mathematician
and philosopher that ever lived, as a multitude of optic
instruments, designed for the separating of light into all
those various colours of which it is composed.

Joseph Addison, Tatler *(1710)*

IRIS

Thou art the iris, fair among the fairest,
 Who, armed with golden rod,
And wingéd with the celestial azure, bearest
 The message of some god.

O! flower-de-luce, bloom on, and let the river
 Linger to kiss thy feet!
O! flower of song, bloom on, and make for ever
 The world more fair and sweet.

Henry Wadsworth Longfellow, 'Flower-de-luce' (1867)

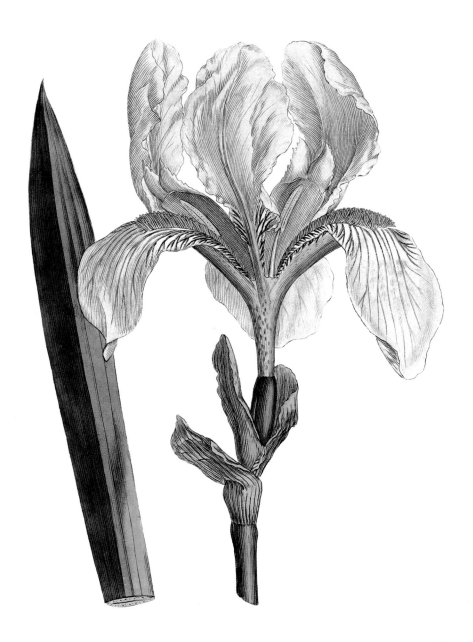

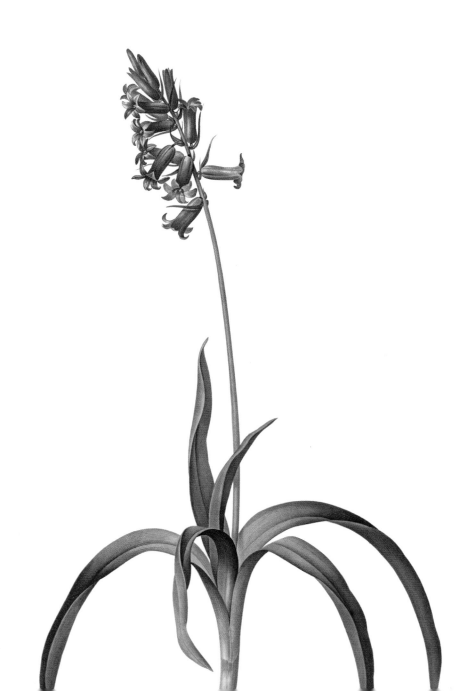

BLUEBELL

Bluebells in Hodder Wood, all hanging their heads one way. I caught as well as I could while my companions talked, the Greek rightness of their beauty, the lovely – what people call – 'gracious' bidding to one another or all one way, the level or stage or shire of colour they make hanging in the air a foot above the grass, and a notable glare the eye may abstract and sever from the blue colour – of light beating up from so many glassy heads, which like water is good to float their deeper instress upon the mind.

Gerard Manley Hopkins, Journal *(1873)*

ROSEMARY

Beauty and Beauty's son and rosemary –
Venus and Love, her son, to speak plainly –
born of the sea supposedly,
at Christmas each, in company,
braids a garland of festivity.
 Not always rosemary –

since the flight to Egypt, blooming differently.
With lancelike leaf, green but silver underneath,
its flowers – white originally –
turned blue. The herb of memory,
imitating the blue robe of Mary,
 is not too legendary

to flower both as symbol and as pungency.
Springing from stones beside the sea,
the height of Christ when thirty-three –
it feeds on dew and to the bee
'hath a dumb language'; is in reality
 a kind of Christmas-tree.

Marianne Moore, 'Rosemary' (1968)

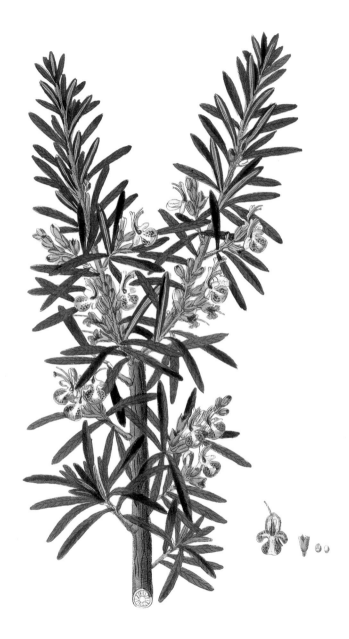

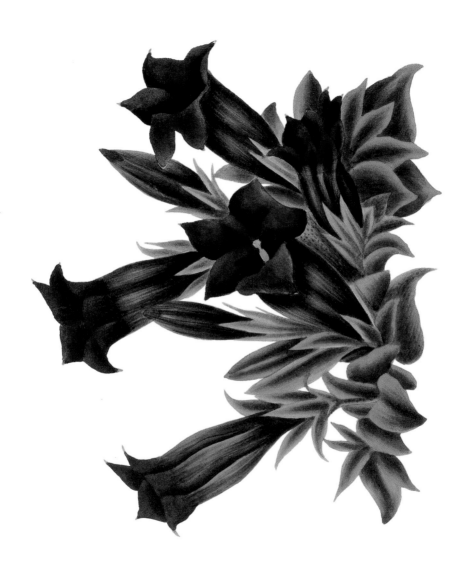

BAVARIAN GENTIAN

Not every man has gentians in his house
in soft September, at slow, sad Michaelmas.

Bavarian gentians, big and dark, only dark
darkening the daytime, torch-like, with the smoking blueness of Pluto's
gloom,
ribbed and torch-like, with their blaze of darkness spread blue
down flattening into points, flattened under the sweep of white day
torch-flower of the blue-smoking darkness, Pluto's dark-blue daze,
black lamps from the halls of Dis, burning dark blue,
giving off darkness, blue darkness, as Demeter's pale lamps give off light,
lead me then, lead the way.

Reach me a gentian, give me a torch!
let me guide myself with the blue, forked torch of this flower
down the darker and darker stairs, where blue is darkened on blueness
even where Persephone goes, just now, from the frosted September
to the sightless realm where darkness is awake upon the dark
and Persephone herself is but a voice
or a darkness invisible enfolded in the deeper dark
of the arms Plutonic, and pierced with the passion of dense gloom,
among the splendor of torches of darkness, shedding darkness on
the lost bride and her groom.

D.H. Lawrence 'Bavarian Gentians' (1932)

HEATHER

You talk of pale primroses,
Of frail and fragrant posies,
The cowslip and the cuckoo-flower
that scent the spring-time lea.
But give to me the heather,
The honey-scented heather,
The glowing gipsy heather –
That is the flower for me!

You love the garden alleys,
Smooth-shaven lawns and valleys,
The cornfield and the shady lane, and
fisher-sails at sea.
But give to me the moorland,
The noble purple moorland,
The free, far-stretching moorland –
That is the land for me!

Flora Thompson, 'Heather' (1921)

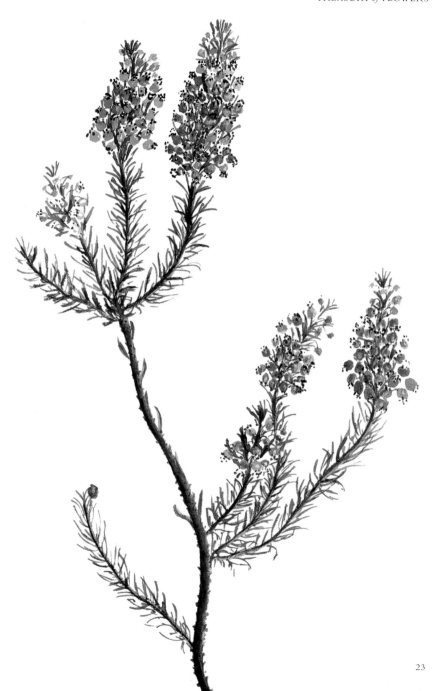

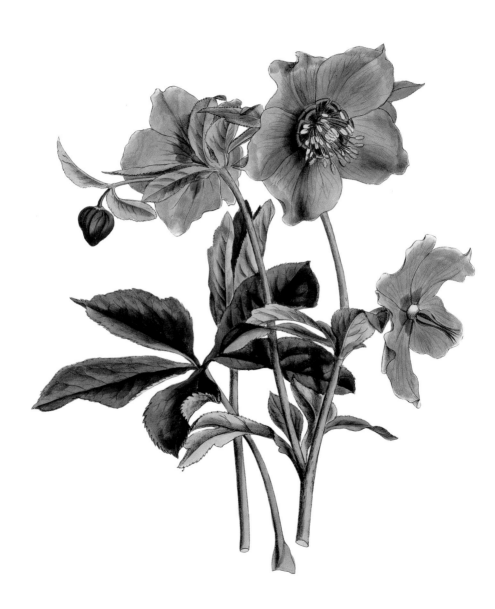

Hellebore

Beautiful in colour these hellebores may not be, but enthralling they certainly are. From green to white and cream, from cream to rose-flushed ivory, pink, amaranth and red, from red to purple, plum-crimson and a velvety darkness that is almost black, they range in an endless variety of shades. And, as that were not enough, their finely modelled bowls indulge in all manner of strange freakings, frecklings, cloudings, stripings and blotching, every individual flower a fantasia of its own caprice. Yet, just as over the colours of all of them one perceives a curious mistiness which subdues the hue even of the brightest, so over all there seems to hang the shadow of some inscrutable gloom.

They are really a little uncanny, these flowers. But need this be surprising in a plant whose very name in its Greek form means 'food to kill'. In the blood of the whole race there lurks not the least deadly of the juices which rendered the herbs of the garden of Persephone so useful to those who once amused themselves by poisoning a friend or removing an enemy. And if, as legend records, it was a spray of hellebore which Eve was permitted to take with her when expelled from Eden, well, unpopular husbands with nasty visions of weed-killer in their minds are not likely to regard the incident with cheerfulness. There seems to have been more than one creature in that first garden which excelled the other beasts of the field in subtlety.

A. T. Johnson, A Woodland Garden *(1937)*

EVENING PRIMROSE

When once the sun sinks in the west
& dew drops pearl the evenings breast
All most as pale as moon beams are
Or its companionable star
The evening primrose opes anew
Its delicate blossoms to the dew
& shunning-hermit of the light
Wastes its fair bloom upon the night
Who blind fold to its fond caresses
Knows not the beauty it posseses
Thus it blooms on till night is bye
& day looks out with open eye
Bashed at the gaze it cannot shun
It faints & withers & is done

John Clare, 'The Midsummer Cushion' (1832)

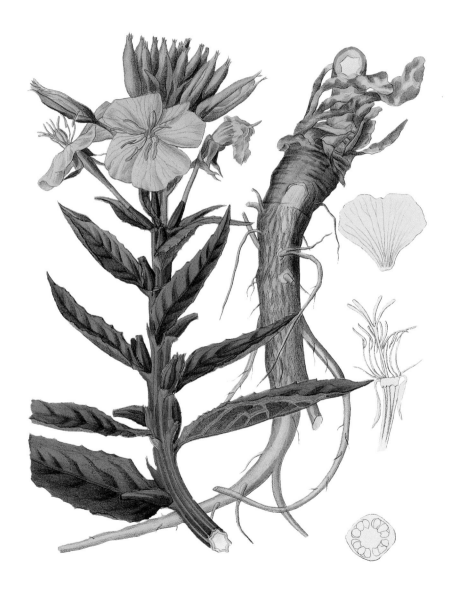

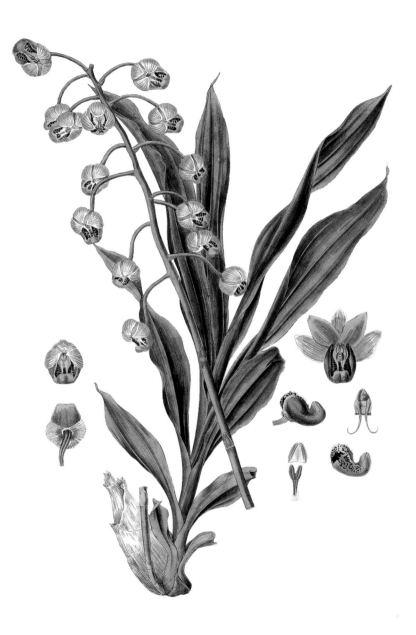

ORCHID

They lean over the path
Adder-mouthed,
Swaying close to the face,
Coming out, soft and deceptive,
Limp and damp, delicate as a young bird's tongue;
Their fluttering fledgling lips
Move slowly
Drawing in the warm air.

And at night,
The faint moon falling through the whitewashed glass,
The heat going down
So their musky smell comes even stronger,
Drifting down from their mossy cradles:
So many devouring infants!
Soft luminescent fingers,
Lips neither dead nor alive,
Loose ghostly mouths
Breathing.

Theodore Roethke, 'Orchids' (1948)

CROWN IMPERIAL

The other fritillary of which I must speak as one of the grandest of April flowers – I might almost say one of the grandest flowers of the year – is the great fritillary, the Crown Imperial. It is a native of Persia, Afghanistan and Cashmere, and was introduced into England from Constantinople about the middle of the sixteenth century and at once took its place as the 'Emperor of Flowers' (Chapman), as the plant which, 'for its stately beautifulnesse, deserveth the first place in our garden of delight' (Parkinson), and George Herbert called it 'a gallant flower, the Crown Imperial.' Perdita put it among her choicest garden flowers; Gerard described it as great length, and with all terms of admiration, and the beautiful French and Dutch books of the period gave excellent engravings of it. From the first, too, it took the name which still remains unto us, and which was at once adopted in all European nations; and the name was happily chosen, for it does not imply that the flower was the emperor of flowers, but it draws attention to a very wonderful arrangement of the flower and seed-vessels. It would be hard to find any plant whose flowers are more completely turned earthwards than the Crown Imperial, yet each flower contains a clear drop of sweet water at the base of the petals, which remains steadily in the flower in defiance of all the laws of gravitation. But no sooner is the flower fully fertilised, and the large seed-pods formed, than, in spite of their great weight, they at once begin to rise, till at last they range themselves in perfect order on the top of the flower stem, forming what it requires little fancy to liken to a well-formed crown with sharp jewelled points. And not only in its name, but in another very remarkable way, the beautiful plant has remained stationary. Though it has been in the hands

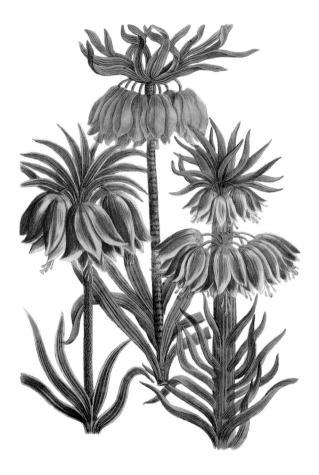

of the gardeners for more than three hundred years, they seem to have been unable to alter, or, as they would say, improve it in any way; so we, at the end of the nineteenth century, have the very same varieties, and no more, that our forefathers had in the sixteenth century.

Canon Ellacombe, In a Gloucestershire Garden *(1895)*

WISTERIA

It has come, it has come again,
This lost blue world
That I have not seen for seven years,
And now there is no other earth beside it.
O what I have missed, these seven eyeless summers,
For this is a blue world shut into itself,
This trellis of wistaria, this blue fire falling;
Its leaves drop flame to every quarter of the winds,
But I lived seven years away and came not to it,
And now the flowers are sevenfold, their honey tongues
Loll like a million bells that quiver and don't ring,
Though the air all trembles and vibrates with them.
Then, as now, their blueness was alive
With quick spangled comedies, quick turncoat rain,
That fell by the trellis and was dyed in that colour;
There was never such a heaping; such a deep piled fullness,
For the flowers lie on the pergola, like snow disastered
From some whirling cataclysm thrown and tumbled.
Let us sit in this cage of fire and think of it!
Why is no poetry so full as this,
But this is mortal with but a breath of life;
Nothing lives outside it, if you keep within,
You have seven days, and a table and a chair;
What else can you wish, you are no prisoner?
Why ever move away from here, there's nothing else?
But keep in this cage of fire and live within it,
Be the salamander in this house of flame;
Look from the windows, see the world on fire.

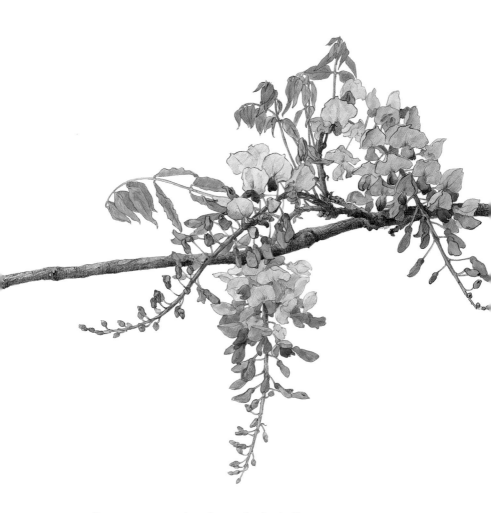

But now comes the aftermath, the hollow empty bathos,
For this blue flower faded at the bat–winged dusk,
It faded and went out into a lifeless nothing;
Nor even did the scent stay in this worse than death.

Sacheverell Sitwell, 'Wistaria: Tuscan' (1936)

PINK

This, this! Is Beauty; cast, I pray, your eyes
On this my Glory! See the Grace, the Size!
Was ever Stem so tall, so stout, so strong,
Exact in breadth, in just proportion, long;
These brilliant Hues are all distinct and clean,
No kindred Tint, no blending Streaks between;
This is no shaded, run-off, pin-ey'd thing,
A King of Flowers, a Flower for England's King:
I own my pride, and thank the favouring Star
Which shed such beauty on my fair *Bizarre*.

George Crabbe, 'The Borough' (1810)

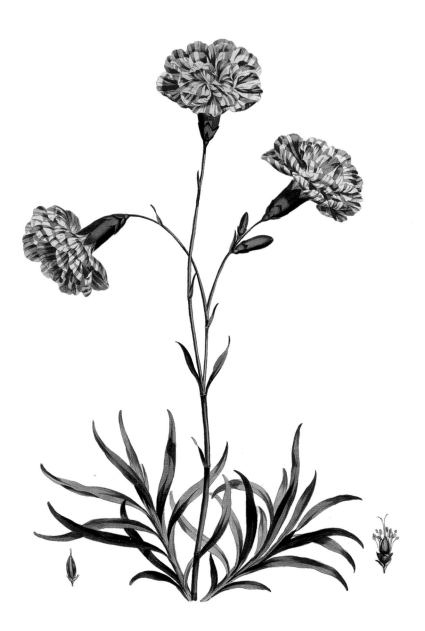

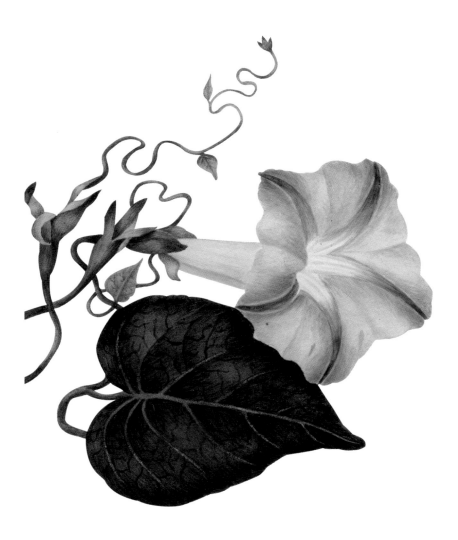

MORNING GLORY

With a pure colour there is little one can do:
Of a pure thing there is little one can say.
We are dumb in the face of that cold blush of blue,
Called glory, and enigmatic as the face of day.

A couple of optical tricks are there for the mind;
See how the azure darkens as we recede:
Like the delectable mountains left behind,
Region and colour too absolute for our need.

Or putting an eye too close, until it blurs,
You see a firmament, a ring of sky,
With a white radiance in it, a universe,
And something there that might seem to sing and fly.

Only the double sex, the usual thing;
But it calls to mind spirit, it seems like the one
Who hovers in brightness suspended and shimmering,
Crying Holy and hanging in the eye of the sun.

And there is one thing more; as in despair
The eye dwells on that ribbed pentagonal round,
A cold sidereal whisper brushes the ear,
A prescient tingling, a prophecy of sound.

Ruth Pitter, 'Morning Glory' (1966)

NIGHT-SCENTED STOCK

Matthiola tristis, the old Night-scented Stock of one's great-grandmother, is another half-hardy indispensable, for I think its scent the sweetest of all those produced by the dingily coloured plants that wake up towards evening and advertise for moths to undertake their pollen dispersal in return for a supper of nectar, and so distil the most wonderfully alluring scents to attract them. This little perennial bushy Stock is not much to look at with its narrow grey leaves and spikes of small lilac and brown flowers; but it beats all the rest of the family in its scent, which has more of Cassia-buds and Russia leather about it than the Cloves or Friar's Balsam I detect even in *Matthiola bicornis,* good as its evening offering of incense can be on a still summer night. I lost my *M. tristis* one Winter; cuttings refused to strike, and moulded off in a way they have if not put in while the sun is still powerful and the air fairly dry, and very few winters spare the old plants outside, and that was not one of them. I tried hard to replace it, but could hear of it nowhere among the nurserymen. Then in Ireland, in a friend's garden, I pryed into the inmost corners of a small greenhouse in spite of being told, 'Oh, there's nothing but rubbish in that old house,' for many a time I have discovered hidden treasure in such half-deserted corners, and this time I saw three pots of fine old specimens of *Matthiola tristis,* a relic of my friend's grandmother and grown there ever since her day; so cuttings from them have restored this sweetest of scents to my garden.

E.A. Bowles, My Garden in Summer *(1914)*

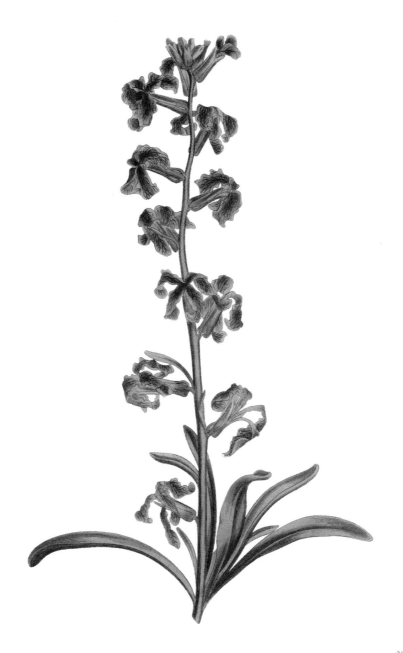

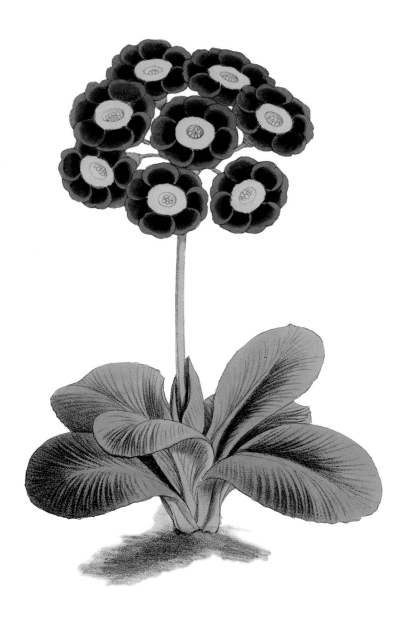

AURICULA

See how the Bears Eares in their several dresses,
(That yet no Poet's pen to hight expresses.)
Each head adornèd with such rich attire,
Which Fools and Clowns may slight, whilst skil'd admire.
Their gold, their purples, scarlets, crimson dyes,
Their dark and lighter hair'd diversities.
With all their pretty shades and Ornaments,
Their parti-colour'd coats and pleasing scents.
Gold laid on scarlet, silver on the blew
With sparkling eyes to take the eyes of you.
Mixt colours, many more to please that sense,
Other with rich and great magnificence,
In double Ruffs, with gold and silver laced,
On purple crimson and so neatly placed.
Ransack Flora's wardrobes, none sure can bring
More taking Ornaments t'adorn the spring.

The Reverend Samuel Gilbert,
The Florist's Vade-Mecum *(1683)*

LILIUM GIGANTEUM

In March the bulbs, which are only just underground, thrust their sharply-pointed bottle-green tips out of the earth. These soon expand into heart-shaped leaves, looking much like Arum foliage of the largest size, and of a bright-green colour and glistening surface. The groups are so placed that they never see the morning sun. They require a slight sheltering of fir-bough, or anything suitable, till the third week of May, to protect the young leaves from the late frosts. In June the flower-stem shoots up straight and tall, like a vigorous young green-stemmed tree. If the bulb is strong and the conditions suitable, it will attain a height of over eleven feet, but among the flowering bulbs of a group there are sure to be some of various heights from differently sized bulbs; those whose stature is about ten feet are perhaps the handsomest. The upper part of the stem bears the gracefully drooping great white Lily flowers, each bloom some ten inches long, greenish when in bud, but changing to white when fully developed. Inside each petal is a purplish-red stripe. In the evening the scent seems to pour out of the great white trumpets, and is almost overpowering, but gains a delicate quality by passing through the air, and at fifty yards away is like a faint waft of incense. In the evening light, when the sun is down, the great heads of white flower have a mysterious and impressive effect when seen at some distance through the wood, and by moonlight have a strangely weird dignity. The flowers only last a few days, but when they are over the beauty of the plant is by no means gone, for the handsome leaves remain in perfection till the autumn, while the growing seed-pods, rising into an erect position, become large and rather handsome objects.

Gertrude Jekyll, Wood and Garden *(1899)*

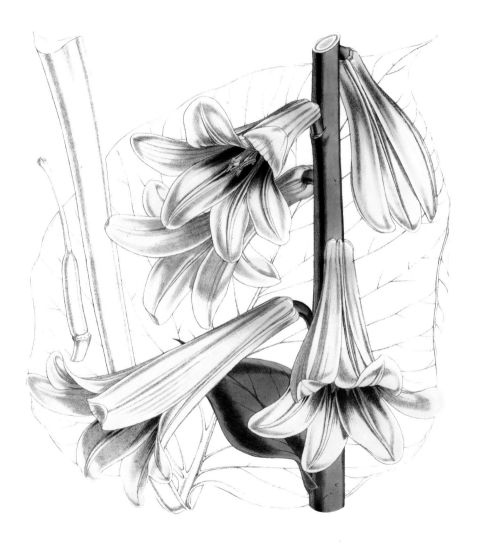

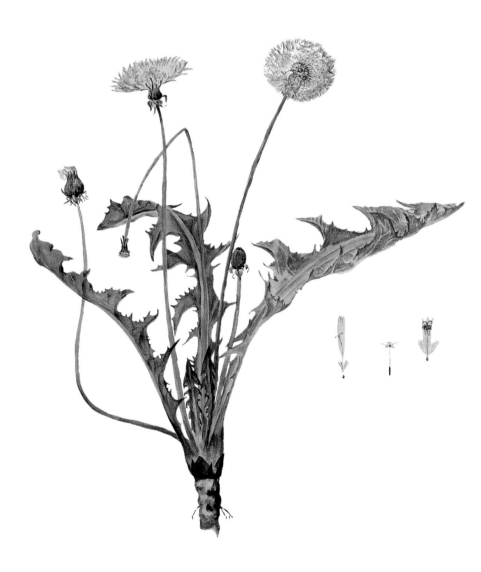

DANDELION

Slugs nestle where the stem
Broken, bleeds milk.
The flower is eyeless: the sight is compelled
By small, coarse, sharp petals,
Like metal shreds. Formed,
They puncture, irregularly perforate
Their yellow, brutal glare.
And certainly want to
Devour the earth. With an ample movement
They are a foot high, as you look.
And coming back, they take hold
On pert domestic strains.
Others' lives are theirs. Between them
And domesticity,
Grass. They infest its weak land;
Fatten, hide slugs, infestate.
They look like plates; more closely
Life the first tryings, the machines, of nature
Riveted into her, successful.

Jon Silkin, 'Dandelion' (1965)

SUNDEW

A little marsh-plant, yellow green,
And pricked at lip with tender red.
Tread close, and either way you tread
Some faint black water jets between
Lest you should bruise the curious head.

A live thing maybe; who shall know?
The summer knows and suffers it;
For the cool moss is thick and sweet
Each side, and saves the blossom so
That it lives out the long June heat.

The deep scent of the heather burns
About it; breathless though it be,
Bow down and worship; more than we
Is the least flower whose life returns,
Least weed renascent in the sea.

We are vexed and cumbered in earth's sight
With wants, with many memories;
These see their mother what she is,
Glad-growing, till August leave more bright
The apple-coloured cranberries.

Wind blows and bleaches the strong grass,
Blown all one way to shelter it
From temple of strayed kine, with feet
Felt heavier than the moorhen was,
Strayed up past patches of wild wheat.

You call it sundew: how it grows,
If with its colour it have breath,
If life taste sweet to it, if death
Pain its soft petal, no man knows:
Man has no sight or sense that saith.

My sundew, grown of gentle days,
In these green miles the spring begun
Thy growth ere April had half done
With the soft secret of her ways
Or June made ready for the sun.

O red-lipped mouth of marsh-flower,
I have a secret halved with thee.
The name that is love's name to me
Thou knowest, and the face of her
Who is my festival to see.

The hard sun, as thy petals knew,
Coloured the heavy moss-water:
Thou wert not worth green midsummer
Nor fit to live to August blue,
O sundew, not remembering her.

Algernon Charles Swinburne, 'The Sundew' (1866)

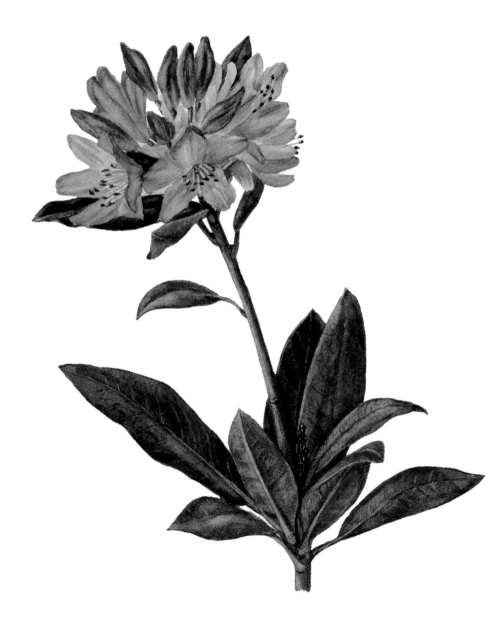

RHODODENDRON

High dormers are rising
So sharp and surprising,
And ponticum edges
The driveways of gravel;
Stone houses from ledges
Look down on ravines.
The vision can travel
From gable to gable.,
Italianate mansion
And turretted stable,
A sylvan expansion
So varied and jolly
Where laurel and holly
Commingle their greens.

John Betjeman,
'An Edwardian Sunday, Broomhill, Sheffield' (1966)

ANEMONE

The anemones likewise or windflowers are so full of variety and so dainty, so pleasant and so delightsome flowers, that the sight of them doth enforce an earnest longing desire in the mind of anyone to be a possessor of some of them at the least. For without all doubt, this one kind of flower, so variable in colours, so differing in form (being almost as many sorts of them double as single), so plentiful in bearing flowers, and so durable in lasting, and also so easy both to preserve and to increase, is of itself alone almost sufficient to furnish a garden with their flowers for almost half the year.

John Parkinson, Paradisi in Sole, Paradisus Terrestris *(1629)*

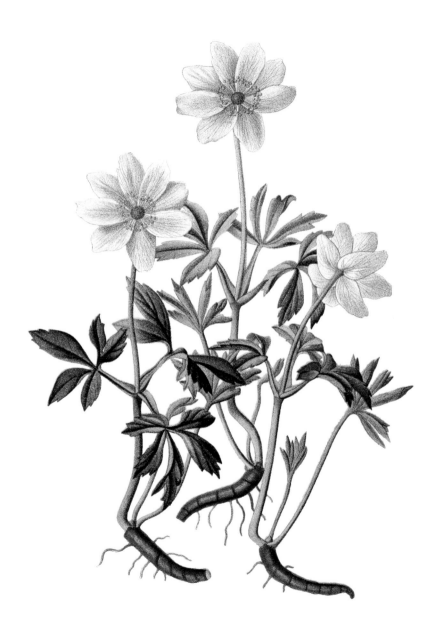

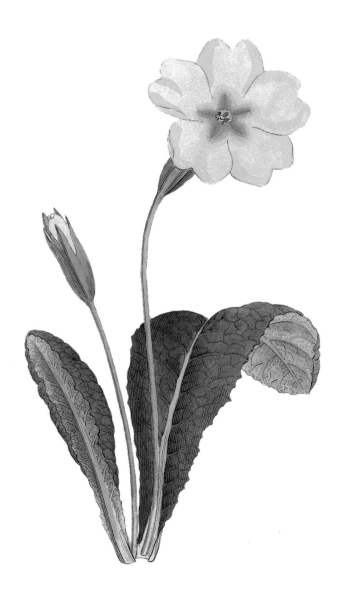

PRIMROSE

Welcome, pale primrose! starting up between
 Dead matted leaves of ash and oak that strew
 The every lawn, the wood, the spinney, through
'Mid creeping moss, and ivy's darker green.
How much thy presence beautifies the ground –
 How sweet thy modest unaffected pride
 Glows on the sunny banks and woods' warm side.

John Clare, 'Primrose' (1820)

ERYTHRONIUM

Another plant which has interesting ways and is beautiful besides is the adder's-tongue, or yellow erythronium, the earliest of the lilies and one of the most pleasing. The April sunshine is fairly reflected in its revolute flowers. The lilies have bulbs that sit on or near the top of the ground. The onion is a fair type of the lily in this respect. But here is a lily with the bulb deep in the ground. How it gets there is well worth investigating. The botany says the bulb is deep in the ground, but offers no explanation. Now, it is only the bulbs of the older or flowering plants that are deep in the ground. The bulbs of the young plants are near the top of the ground. The young plants have but one leaf, the older or flowering ones have two. If you happen to be in the woods at the right time in early April, you may see these leaves compactly rolled together, piercing the matted coating of sere leaves that covers the ground like some sharp-pointed instrument. They do not burst their covering or lift it up but pierce through it like an awl.

But how does the old bulb get so deep into the ground? In digging some of them up one spring in an old meadow bottom, I had to cleave the tough fibrous sod to a depth of eight inches. The smaller ones were barely two inches below the surface. Of course they all started from the seed at the surface of the soil. The young botanist or nature lover will find here a field for original research. If, in late May or early June, after the leaves of the plant have disappeared, he finds the ground where they stood showing curious, looping, twisting growths or roots of a greenish white color, let him examine them. They are as smooth and as large as an angleworm, and very brittle. Both ends will be found in the ground, one attached to the old bulb,

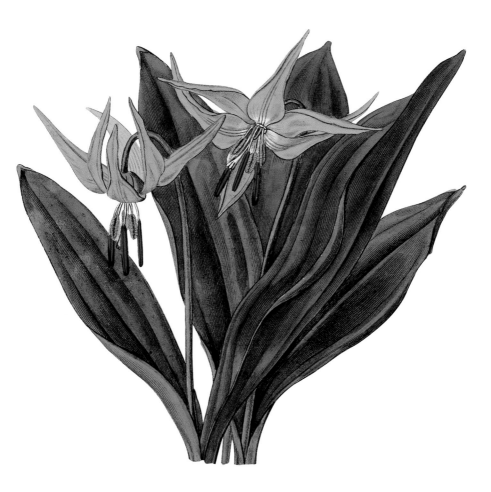

the other boring or drilling downward and enlarged till it suggests the new bulb. I do not know that this mother root in all cases comes to the surface. Why it should come at all is a mystery, unless it be in some way to get more power for the downward thrust. My own observations upon the subject are not complete, but I think in the foregoing I have given the clew as to how the bulb each year sinks deeper and deeper into the ground.

It is a pity that this graceful and abundant flower has no good and appropriate common name. It is the earliest of the true lilies, and it has all the grace and charm that belong to this order of flowers. *Erythronium*, its botanical name, is not good, as it is derived from a Greek word that means red, while one species of our flower is yellow and the other is white. How it came to be called 'adder's-tongue' I do not know; probably from the spotted character of the leaf, which might suggest a snake, though it in no wise resembles a snake's tongue. A fawn is spotted, too, and 'fawn lily' would be better than 'adder's-tongue.' Still better is the name 'trout lily,' which has recently been proposed for this plant. It blooms along the trout streams, and its leaf is as mottled as a trout's back. The name 'dog's-tooth' may have been suggested by the shape and color of the bud, but how the 'violet' came to be added is a puzzle, as it has not one feature of the violet. It is only another illustration of the haphazard way in which our wild flowers, as well as our birds, have been named.

John Burroughs, Signs and Seasons *(1886)*

AMARANTH

Immortal Amaranth! a flower which once
In paradise, fast by the tree of life
Began to bloom; but soon, for man's offence,
To heaven removed, where first it grew, there grows
And flowers aloft, shading the tree of life.

John Milton, Paradise Lost *(1667)*

OLD MAN

Old Man, or Lad's-love, – in the name there's nothing
To one that knows not Lad's-love, or Old Man,
The hoar-green feathery herb, almost a tree,
Growing with rosemary and lavender.
Even to one that knows it well, the names
Half decorate, half perplex, the thing it is:
At least, what that is clings not to the names
In spite of time. And yet I like the names.

The herb itself I like not, but for certain
I love it, as some day the child will love it
Who plucks a feather from the door-side bush
Whenever she goes in or out of the house.
Often she waits there, snipping the tips and shrivelling
The shreds at last on to the path, perhaps
Thinking, perhaps of nothing, till she sniffs
Her fingers and runs off. The bush is still
But half as tall as she, though it is as old;
So well she clips it. Not a word she says;
And I can only wonder how much hereafter
She will remember, with that bitter scent,
Of garden rows, and ancient damson trees
Topping a hedge, a bent path to a door,
A low thick bush beside the door, and me
Forbidding her to pick.
As for myself,
Where first I met the bitter scent is lost.
I, too, often shrivel the grey shreds,
Sniff them and think and sniff again and try

Once more to think what it is I am remembering,
Always in vain. I cannot like the scent,
Yet I would rather give up others more sweet,
With no meaning, than this bitter one.
I have mislaid the key. I sniff the spray
And think of nothing; I see and I hear nothing;
Yet seem, too, to be listening, lying in wait
For what I should, yet never can, remember:
No garden appears, no path, no hoar-green bush
Of Lad's-love, or Old Man, no child beside,
Neither father nor mother, nor any playmate;
Only an avenue, dark, nameless, without end.

Edward Thomas, 'Old Man' (1917)

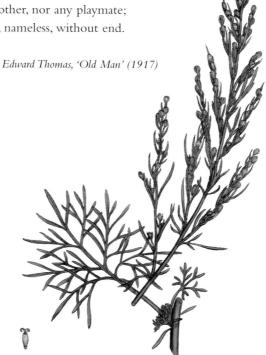

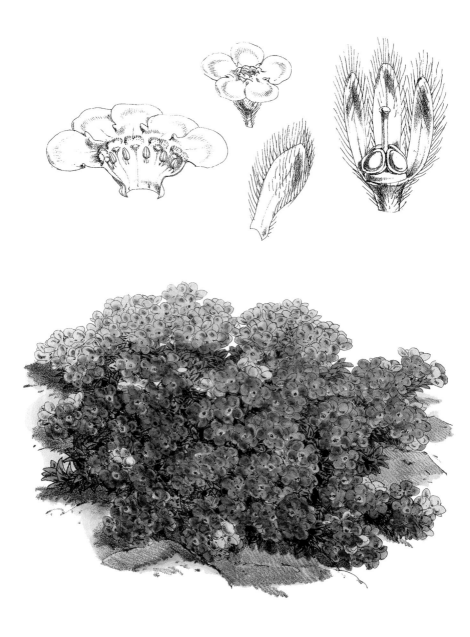

ALPINE FORGET-ME-NOT

Ah, the blessed little creature, how it takes one captive! The first sight of it catches one by the throat. So exquisite, so tiny, this indomitable small soul sits up here on the barren slopes, from age to age, working out its own destiny without regard for any worldly cataclysm. Even the loveliness of it seems almost a heavenly selfishness. Little does *Eritrichium* care whether anyone worships it or no! Alone, unfriended, it braves all the everlasting fury of the hills; sits quiet through thelong Alpine winters; then during the short gorgeous Alpine summer, makes haste to smile at the sun before the dark days return.

Reginald Farrer, My Rock Garden *(1920)*

POPPY

While summer roses all their glory yield
 To crown the votary of love and joy,
 Misfortune's victim hails, with many a sigh,
 Thee, scarlet Poppy of the pathless field,
Gaudy, yet wild and lone; no leaf to shield
 Thy flaccid vest that, as the gale blows high,
 Flaps, and alternate folds around thy head.
 So stands in the long grass a love-crazed maid,
Smiling aghast; while stream to every wind
 Her garish ribbons, smeared with dust and rain;
 But brain-sick visions cheat her tortured mind,
And bring false peace. Thus, lulling grief and pain,
 Kind dreams oblivious from thy juice proceed,
 Thou flimsy, showy, melancholy weed.

Anna Seward, 'Sonnet: To the Poppy' (c. 1789)

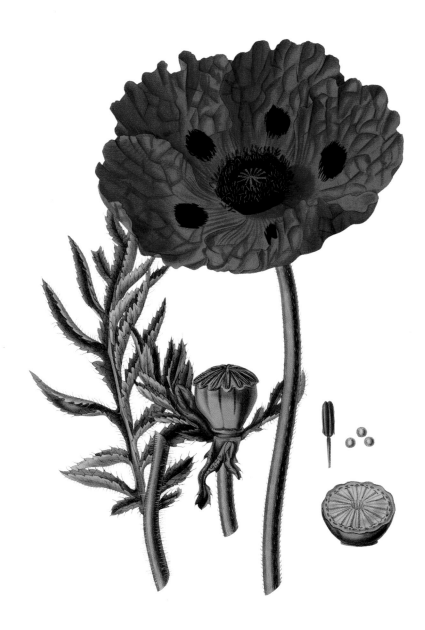

FUCHSIA

Mrs Masters's fuchsias hung
Higher and broader, and brightly swung,
 Bell-like, more and more
Over the narrow garden-path,
Giving the passer a sprinkle-bath
 In the morning.

She put up with their pushful ways,
And made us tenderly lift their sprays,
 Going to her door:
But when her funeral had to pass
They cut back all the flowery mass.

Thomas Hardy, 'The Lodging-House Fuchsias' (1928)

GERANIUM

In the window beside which we are writing this article, there is a geranium shining with its scarlet tops in the sun, the red of it being the more red for a background of lime-trees which are at the same time breathing and panting like airy plenitudes of joy, and developing their shifting depths of light and shade, of russet browns and sunny inward gold.

It seems to say, 'Paint me!' so here it is. Every now and then some anxious fly comes near it: – we hear the sound of a bee, though we see none; and upon looking closer at the flowers, we observe that some of the petals are transparent with the light, while others are left in shade; the leaves are equally adorned, after their opaquer fashion, with those effects of the sky, showing their dark brown rims; and on one of them a red petal has fallen, where it lies on the brighter half of the shallow green cup, making its own redder, and the green greener. We perceive in imagination, the scent of those good-natured leaves, which allow you to carry off their perfume on your fingers; for good-natured they are in that respect, above almost all plants, and fittest for the hospitalities of your rooms. The very feel of the leaf has a household warmth in it something analogous to clothing and comfort.

Leigh Hunt 'A Flower for your Window' (1840)

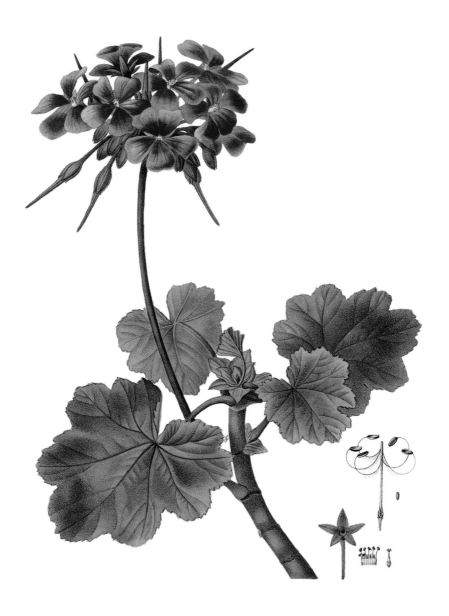

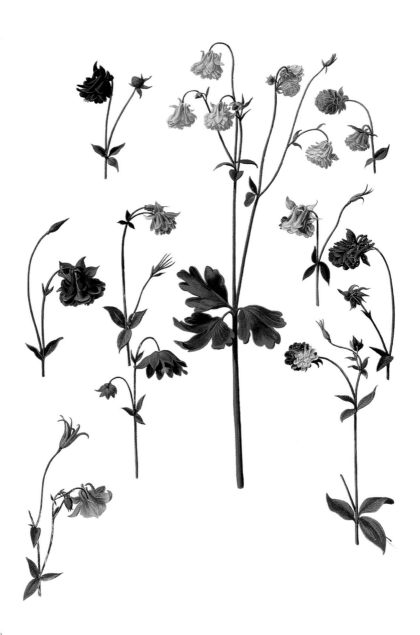

COLUMBINE

Not nearly enough use is made of that airy flower, the modern columbine. Even our old native *Aquilegia vulgaris* has its charm. Who could resist anything nicknamed Granny's Bonnet or Doves-round-a-dish? I never have the heart to tear it out from wherever it has chosen to sow itself, though I know that it is little more than a weed and is a nuisance in that it hybridizes to the detriment of the choicer kinds. In fact, there are few flowers better disposed to hybridize amongst themselves, or, as one nurseryman puts it, 'their morals leave much to be desired.' In the case of the columbines, however, this is part of their attraction, for it means you may get chance seedlings of a colour you never anticipated.

Let me list their other advantages. They are perennial, which saves a lot of bother. They are hardy. They are light and graceful in a mixed bunch. They will put up with a certain amount of shade. They are easily grown from seed, and may be had in a surprising range of height and hue, from the tiny blue alpina whose inch of stature makes it suitable for rockeries, to the 3-ft. long-spurred hybrids in yellow, white, blue, mauve, pink, crimson-and-gold; and even, if you want something really out of the way, in green-and-brown. This last one is called *viridiflora*, and is about a foot high.

For any lucky person with the space to spare, I could imagine a small enclosed garden or, say, a three-sided courtyard such as you often find in old farmhouses. If the courtyard happened to be paved with flagstones, so much the better, for, as I never tire of saying, plants love to get between the cracks and send their roots down into the cool reaches of the soil beneath, thus preserving themselves from the minor enemy of frost and from the major enemy of damp. It is just such a little walled garden or courtyard that I envisage, blowing with a coloration of columbines.

V. Sackville-West, Even More for your Garden *(1955)*

JASMINE

Plants that wake when others sleep –
Timid jasmine buds that keep
Their fragrance to themselves all day,
But when the sunlight dies away
Let the delicious secret out
To every breeze that roams about.

Thomas Moore, 'Lalla Rookh' (1817)

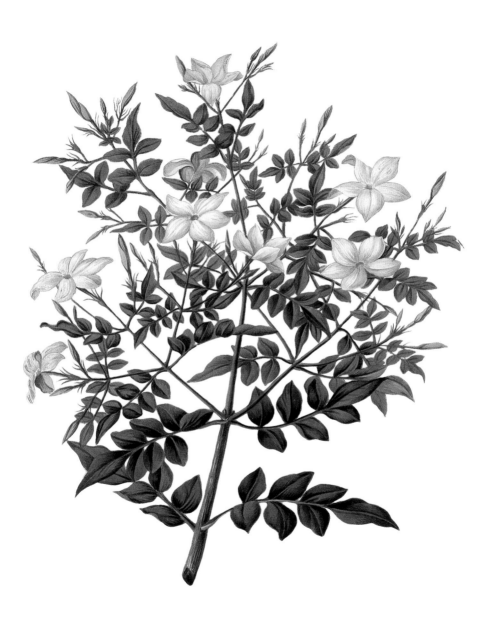

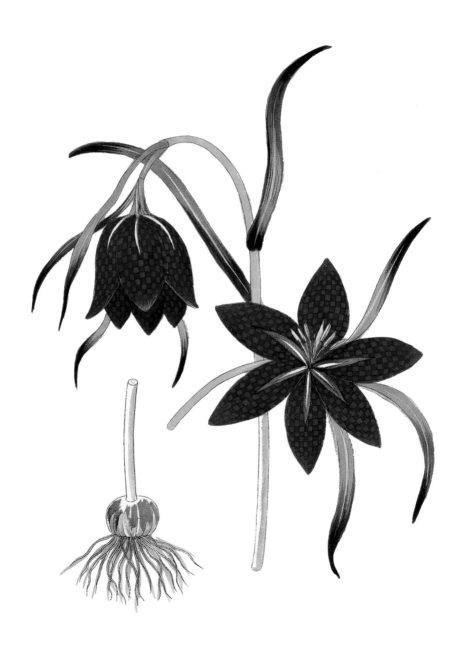

Snakeshead Fritillary

Some seedlings shoulder the earth away
Like Milton's lion plunging to get free,
Demanding notice. Delicate rare fritillary,
You enter creeping, like the snake
You're named for, and lay your ear to the ground.
The soundless signal comes, to arch the neck – Losing
the trampled look –
Follow the code for colour, whether
White or freckled with purple and pale,
A chequered dice-box tilted over the soil,
The yellow dice held at the base.

When light slants before the sunset, this is
The proper time to watch fritillaries.
They enter creeping; you go on your knees,
The flowers level with your eyes,
And catch the dapple of sunlight through the petals.

Anne Ridler, 'Snakeshead Fritillaries' (1994)

LILIUM REGALE

The rose sleeps in her beauty, but the lily seems unaware of her own exceeding loveliness. The rose is never so glorious as in cultivation and fares sumptuously, with every care lavished on her but, given rich food instead of the sharp drainage and leaf mould to which she is accustomed, the lily withdraws her gracious presence. The purity of the lily is not only in her outward form, but it is characteristic of the food she requires. No members of the lily family tolerate manure, artifical or otherwise. The lily is at her fairest in the waste places of the earth, where human eyes rarely see her in her beauty. Think of the splendour of *Lilium regale* in her native haunts where her discoverer, the late Mr E.H. Wilson, found her, in that little-known, wild territory which separates China proper from mysterious Thibet. In the narrow valleys bordering on the roof of the world, in a region dominated by lofty peaks crowned with eternal snows, subjected to intense cold in winter and terrific heat in summer, in solitudes where only a few intrepid explorers and wild tribesmen venture, the regal lily reigns. Both in summer and winter these regions are swept by storms of awe-inspiring violence, yet in June the precipitous, arid mountain-sides blossom with countless thousands of these glorious lilies filling the air with their wondrous perfume. And from her mountainous fastness this radiant queen has been transported to our gardens. When one looks at her with the rich wine-colour shining through the snow-white inner surface of her petals and her golden anthers in this exquisite setting, and bearing sometimes as many as fifteen flowers on each slender stalk, it seems as though one so gorgeously apparelled must live delicately in Kings' courts, yet her dwelling is amidst the bleaskest solitudes of this planet. Still stranger is it that this lily ripens seed freely in this country; the seeds germinate in a few weeks and the plants flower after their second year.

Eleanour Sinclair Rohde, The Scented Garden *(1931)*

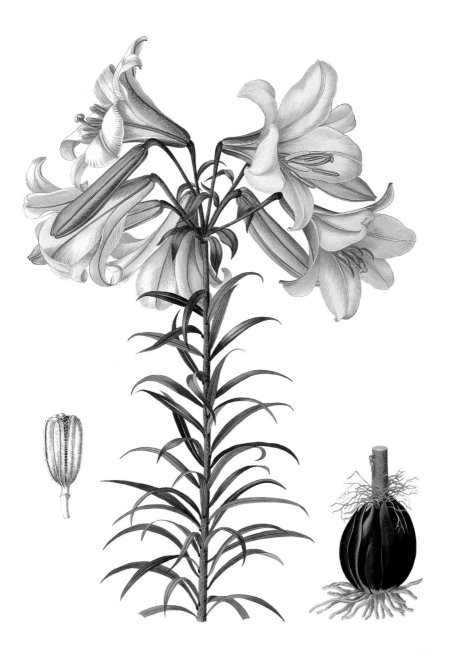

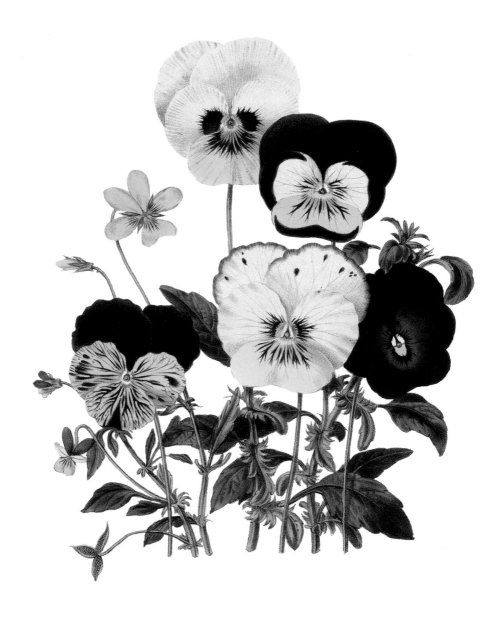

PANSY

Yet marked I where the bolt of Cupid fell.
It fell upon a little western flower,
Before milk-white, now purple with love's wound,
And maidens call it love-in-idleness.

William Shakespeare, A Midsummer Night's Dream *(1590s)*

SUNFLOWER

Stately stand the sunflowers, glowing down the garden-side,
Ranged in royal rank arow along the warm grey wall,
Whence their deep disks burn at rich midnoon afire with pride,
Even as though their beams indeed were sunbeams, and the tall
Sceptral stems bore stars whose reign endures, not flowers that fall.

Algernon Charles Swinburne, 'The Mill Garden' (1884)

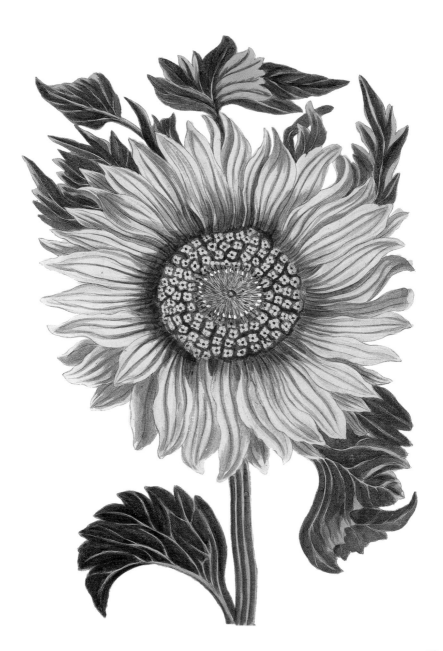

ROSE

A large rose-tree stood near the entrance of the garden: the roses growing on it were white, but there were three gardeners at it, busily painting them red. Alice thought this a very curious thing, and she went nearer to watch them, and just as she came up to them she heard one of them say 'Look out now, Five! Don't go splashing paint over me like that!'

'I couldn't help it,' said Five, in a sulky tone. 'Seven jogged my elbow.'

On which Seven looked up and said 'That's right, Five! Always lay the blame on others!'

'You'd better not talk!' said Five. 'I heard the Queen say only yesterday you deserved to be beheaded!'

'What for?' said the one who had first spoken.

'That's none of your business, Two!' said Seven.

'Yes, it is his business!' said Five. 'And I'll tell him – it was for bringing the cook tulip roots instead of onions.'

Seven flung down his brush, and had just begun 'Well, of all the unjust things –' when his eye chanced to fall upon Alice, as she stood watching them, and he checked himself suddenly: the others looked round also, and all of them bowed low.

'Would you tell me,' said Alice, a little timidly, 'why you are painting these roses?'

Five and Seven said nothing, but looked at Two. Two began in a low voice, 'Why, the fact is, you see, Miss, this here ought to have been a red rose-tree, and we put a white one in by mistake; and if the Queen was to find it out, we should all have our heads cut off, you know. So you see, Miss, we're doing our best, afore she comes,

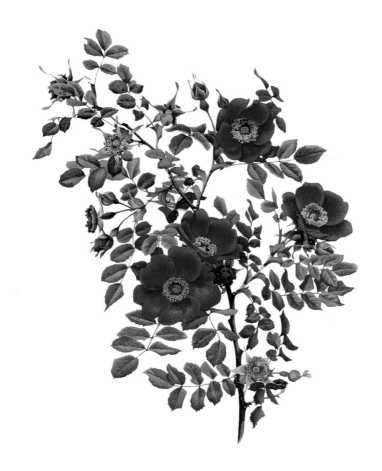

to –' At this moment, Five, who had been anxiously looking across the garden, called out 'The Queen! The Queen!' and the three gardeners instantly threw themselves flat upon their faces. There was a sound of many footsteps, and Alice looked round, eager to see the Queen.

Lewis Carroll, Alice's Adventures in Wonderland *(1865)*

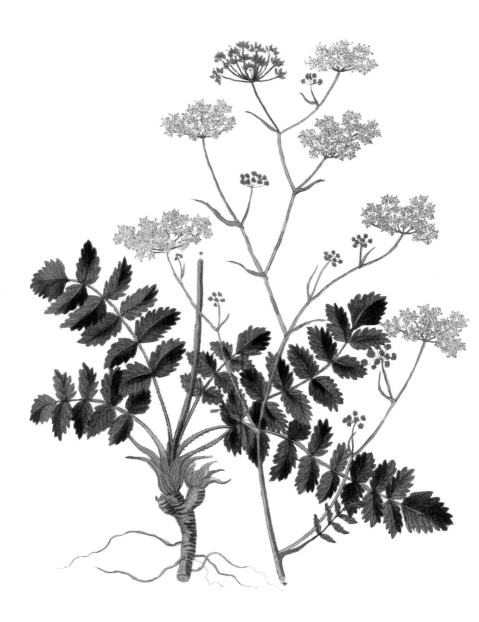

Greater Burnet Saxifrage

Another very good mixer is a very plebeian plant, *Pimpinella major rosea*, which is nothing more than a pink cow parsley. Ferny leaves and rather dull pink flowers are a good foil for any strong-coloured or bold plant. I happened to plant it near the deep blue *Campanula glomerata*, with its clustered heads, and both plants are better for the association. I have never given much thought to the cow parsley and was rather shaken when a visitor from a distance who spent a long time doing the garden, told me at the end of the tour that seeing the cow parsley had made his day and he would have come any distance to see it! It made me feel unappreciative and I went back to look at it spreading its delicate leaves under the Judas tree, and in another place where it was growing with *Polemonium caeruleum* and the striped grass, *Phalaris arundinacea variegata*, with a blue cedar as background.

It is always a great pleasure – and surprise – when you happen on just the perfect place in which to plant some special treasure.

Margery Fish, A Flower for Every Day *(1965)*

LENT LILY

'Tis spring; come out to ramble
The hilly brakes around,
For under thorn and bramble
About the hollow ground
The primroses are found.

And there's the windflower chilly
With all the winds at play,
And there's the Lenten lily
That has not long to stay
And dies on Easter day.

And since till girls go maying
You find the primrose still,
And find the windflower playing
With every wind at will,
But not the daffodil,

Bring baskets now, and sally
Upon the spring's array,
And bear from hill and valley
The daffodil away
That dies on Easter day.

A.E. Housman, A Shropshire Lad *(1896)*

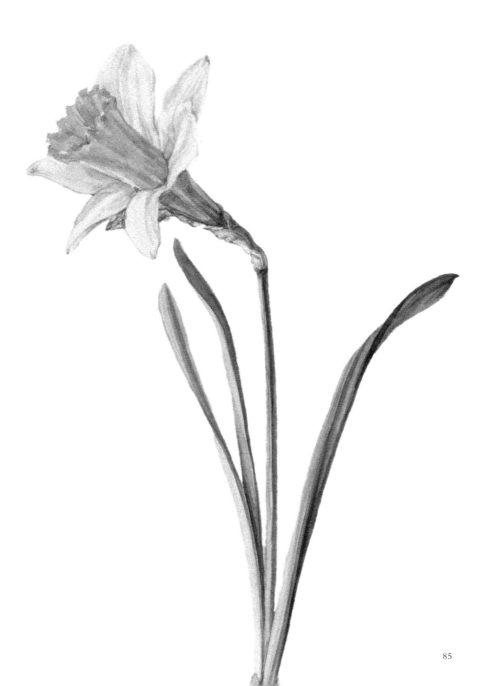

WOODSPURGE

The wind flapped loose, the wind was still,
Shaken out dead from tree and hill;
I had walked on at the wind's will –
I sat now, for the wind was still.

Between my knees my forehead was –
My lips, drawn in, said not Alas!
My hair was over in the grass,
My naked ears heard the day pass.

My eyes, wide open, had the run
Of some ten weeds to fix upon;
Among those few, out of the sun,
The woodspurge flowered, three cups in one.

From perfect grief there need not be
Wisdom or even memory;
One thing then learned remains to me –
The woodspurge has a cup of three.

Dante Gabriel Rossetti, 'Woodspurge' (1870)

PEONY

Here they are, they've come, those peonies you say smell like a rose, themselves the forerunners of the earliest rose. Give them plenty of water, these gorgeous corollas, which indeed do have something of the rose about them, something, but not its scent.

Garnet-red, cheerful pink, sentimental pink and three or four other carmines, they are all of a healthy colour and will rejoice my heart throughout the week. Then, all at once, they will let their glowing embers fall with the sigh of a flower that imitates the abrupt decease of the rose. Its decease, but not its scent. For the peony does not smell like a rose and I am the last person to reproach it for that. The peony smells like a peony. You really must take my word for it, instead of always seeking comparisons, saying that fresh butter has a nutty flavour, that pineapples taste of wild strawberries, and the white strawberry has the soft and appetising savour of crushed ants!

The peony smells of peonies, that is to say of cockchafers. Its slightly rank if delicate scent acts as an interpreter, and thus it has he privilege of putting us in mind of the spring proper, bearer of many suspect scents, the sum total of which is calculated to enchant us. The lilac, before it flowers, when it is still nothing but small leaves like aces of spades and shows promise of becoming a midget thyrsus, the lilac then has a discreet smell of scarab-beetles, right up to the moment when in full flower the sprays foam into white, mauve, blue, and purple, and it drenches suburban trains, undergrounds and children's play-pens with its toxic aroma of prussic acid. Then I regret the scent of the lilac while still in bud, the scent of its tender brown leaflets, its fleeting exhalation, to some degree both repugnant and agreeable, of wing-sheath insects. That is why, in the name of the spring I insult, you will cease to like me and refuse to understand me. That is why I retire to my modest lair, along paths embroidered perchance by the wild geranium, known as herb-Robert, with its insignificant flowrets and seeds the shape of a crane's bill. If by accident you happen to brush your fingers against it they will retain a sharp fragrance, a little too keen to be agreeable.

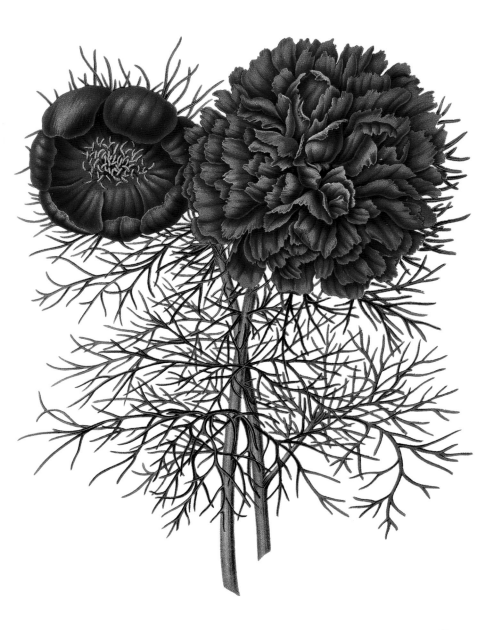

I myself take pleasure in crushing its purplish stem and leaves, for this sets me dreaming — as one of my she-cats would muse over mysterious messages relayed from freshly tanned leather: she sniffed it, then decamped. She returned, and stepped gingerly about while swishing her tail, and the performance ended in a series of infinitesimal retchings delicately suppressed. I never go as far as that with herb-Robert. I could name a number of other plants which most of you will find repellent, whereas I split them open with my nail and sniff the milk white blood of the spurge, the ochre-tinted juice of the greater celandine, called tetterwort, and by corruption 'clear-basins'.

I prefer the harsh fragrance that rises from a sligthly sinister or medicinal herb, supposedly poisonous, to that of the insipid elder or even to that of the privet, so sickly sweet and heavy that when in full flower it commands our respect along the lanes behind Cancale. Do you spurn the bark of the gean? I find it congenial, believe me. But then how many are the bottled scents I find disappointing! To make up for this, what a splendid incense to my independent and capricious olfactory nerve system is provided by the wild onrush that rises, in summer, from chlorophyl leaf-green ripped off in a storm, the iodine deposited at every low tide, the stench belched forth by the kitchen garden that can contain it no longer, from the heaps of rotting vegetal rubbish in which ferment a congeries of black currant marc, uprooted fennel, and old dahlia bulbs!

What then have I been trying to tell you? That the peony scents the air, smelling not of peony, nor of rose, but of cockchafers? That the lilac, if too close a neighbour to our bedroom, is a horribly hydrocyanic lover? That the tansy — 'the evilsmelling tansy' as the botanists call it — and the achillea, put new heart in my stomach and even enhearten me, that on the contrary the sick-making vanilla of the heliotrope and its half mourning mauve put me to inconvenience? Good Lord, it did not require so many words and lines to say that.

Colette, Flowers and Fruit, *translated by Matthew Ward (1986)*

CELANDINE

Pleasures newly found are sweet
When they lie about our feet:
February last, my heart
First at sight of thee was glad;
All unheard of as thou art,
Thou must needs, I think, have had,
Celandine! and long ago,
Praise of which I nothing know.

I have not a doubt but he,
Whosoe'er the man might be,
Who the first with pointed rays
(Workman worthy to be sainted)
Set the sign-board in a blaze,
When the rising sun he painted,
Took the fancy from a glance
At thy glittering countenance.

Often have I sighed to measure
By myself a lonely pleasure,
Sighed to think, I read a book
Only read, perhaps, by me;
Yet I long could overlook
Thy bright coronet and Thee,
And thy arch and wily ways,
And thy store of other praise.

Blithe of heart, from week to week
Thou dost play at hide-and-seek;
While the patient primrose sits
Like a beggar in the cold,
Thou, a flower of wiser wits,
Slipp'st into thy sheltering hold;
Liveliest of the vernal train
When ye all are out again.

Drawn by what peculiar spell,
By what charm of sight or smell,
Does the dim-eyed curious Bee,
Labouring for her waxen cells,
Fondly settle upon Thee
Prized above all buds and bells
Opening daily at thy side,
By the season multiplied?

Thou art not beyond the moon,
But a thing 'beneath our shoon:'
Let the bold Discoverer thrid
In his bark the polar sea;
Rear who will a pyramid;
Praise it is enough for me,
If there be but three or four
Who will love my little Flower.

William Wordsworth, 'To the Same Flower' (1803)

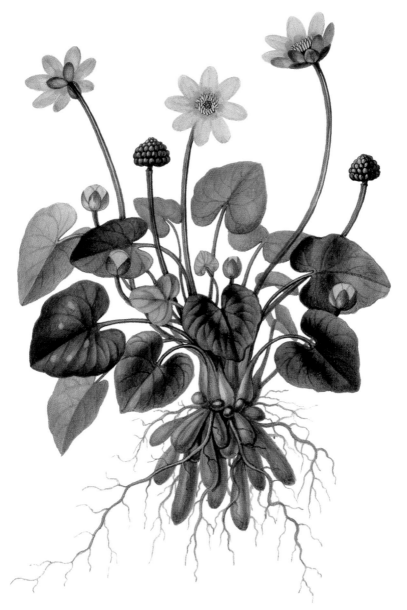

BIRD'S FOOT TREFOIL

It was now the season when the bird's-foot-trefoil, one of the
commonest plants of the downland country, was in its fullest
bloom, so that in many places the green or grey-green turf as
far as one could see on every side was sprinkled and splashed
with orange-yellow. Now this creeping, spreading plant, like
most plants that grow on the close-cropped sheep-walks,
whose safety lies in their power to root themselves and live
very close to the surface, yet must ever strive to lift its flowers
into the unobstructed light and air and to overtop or get away
from its crowding neighbours. On one side of the road, where
the turf had been cut by the spade in a sharp line, the plant
had found a rare opportunity to get space and light and had
thrust out such a multitude of flowering sprays, projecting
them beyond the turf, as to form a close band or rope of
orange-yellow, which divided the white road from the green
turf, and at one spot extended unbroken for upwards of a
mile. The effect was so singular and pretty that I had haunted
this road for days for the pleasure of seeing that flower border
made by nature. Now all colour was extinguished: beneath
and around me there was a dimness which at a few yards'
distance deepened to blackness, and above me the pale dim
blue sky sprinkled with stars; but as I walked I had the image
of that brilliant band of yellow colour in my mind.

W.H. Hudson, Afoot in England *(1909)*

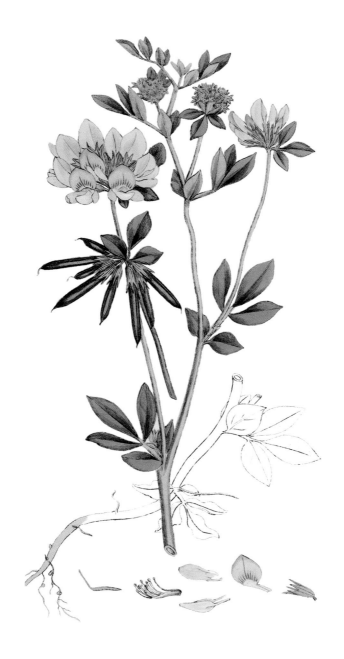

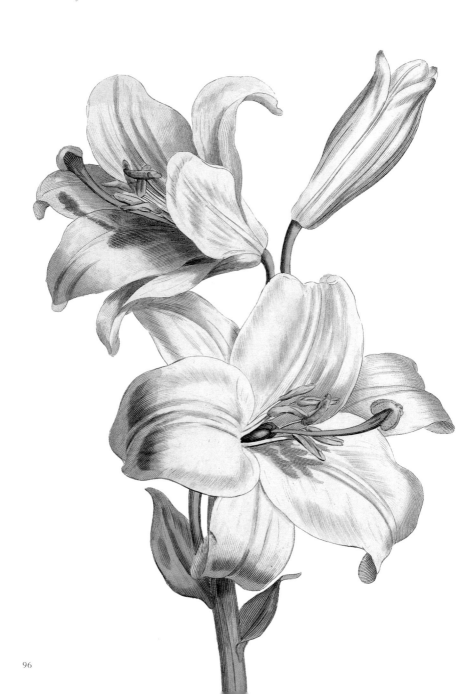

LILY

I have a Garden of my own,
But so with Roses over grown,
And Lillies, that you would it guess
To be a little Wilderness.
And all the Spring time of the year
It onely loved to be there.
Among the beds of Lillyes, I
Have sought it oft, where it should lye;
Yet could not, till it self would rise,
Find it, although before mine Eyes.
For, in the flaxen Lillies shade,
It like a bank of Lillies laid.
Upon the Roses it would feed,
Until its Lips ev'n seem'd to bleed:
And then to me 'twould boldly trip,
And print those Roses on my Lip.
But all its chief delight was still
On Roses thus its self to fill:
And its pure virgin Limbs to fold
In whitest sheets of Lillies cold.
Had it liv'd long, it would have been
Lillies without, Roses within.

Andrew Marvell, The Nymph Complaining
for the Death of her Faun (c. 1650)

BROOM

On me such bounty Summer pours
That I am covered o'er with flowers;
And, when the Frost is in the sky,
My branches are so fresh and gay
That you might look at me and say,
This Plant can never die.

'The butterfly, all green and gold,
To me hath often flown,
There in my blossoms to behold
Wings lovely as his own.'

William Wordsworth,
'The Oak and the Broom' (1800)

PLUMBAGO

The plumbago or blue leadwort is a plant that would be reckoned among the most valuable in all the flowery kingdom if there were any justice or true sense of proportion in the world. When it is in bloom, seething with cobalt and smartly attacking the eye with its brilliance, not even gentians surpass it in its color, and in addition to that it has assorted merits so great that any one of them entitles it to attention.

It grows about a foot high with leaves somewhat like a periwinkle's, and in the late spring (it sprouts its leaves only after spring has really come) it starts sitting there looking like a small broadleaf evergreen. It is not an evergreen and it is not woody, it dies back every winter, and yet if you didn't know better, you might think it was a vinca or a small andromeda. All summer it sits there biding its time and going from strength to strength in a controlled, sturdy way. It is not one of those things that has raced five feet off from where you planted it. No, it spreads reasonably but knows nothing about how to become a weed.

Then, in late July, or in August, an occasional nickel-sized flower will appear at the tip of a shoot and these burst forth with increasing energy in September and continue, slowing down a bit, until late October. The buds appear in densely packed clusters at the end of the shoots and open in succession, though often with half a dozen or so open at once in each cluster.

In any case, it is not the individual flower that one admires so much as the carpet sprigged all over with deep and highly charged blue. You either go to pieces over blue or you don't, but most gardeners do. Even azure and violet are not to be sneezed at, since there are so few flowers that can rightly be called blue. But this leadwort is blue. It has, like most blues that make you blink, a good bit of unexpressed red in it. The little bracts at the base of the flowers are rosy bronze or even purplish. Usually you don't consciously notice them but I think they have something to do with the general effect of brilliance.

After the flowers are all gone, the reddish bracts remain for a bit, and the foliage of the plant itself often (almost always) turns to rich bronze and red. So even when the fall turns cold the plant is handsome in its modest way, which is the best way for anything to be handsome, as we know.

The great Victorian authority on everything in gardens was William Robinson, to whom gardeners owe all. He was only moderately awed by the leadwort, partly because he went mad for asters, which bloom at the same time. Perhaps he found it hard to admit that no aster rivals the leadwort for color. And, unlike asters, there is nothing weedy or second-rate or make-do about the leadwort, which is an aristocrat.

Henry Mitchell, The Essential Earthman *(1981)*

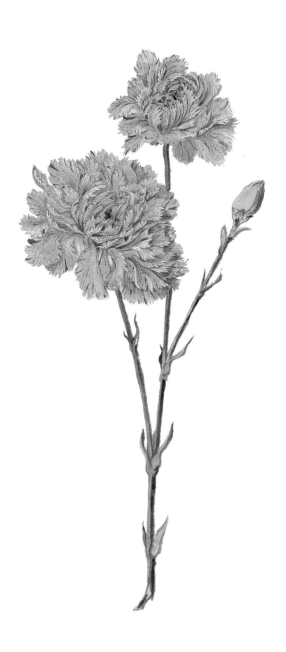

CARNATION

Pale blossoms, each balanced on a single jointed stem,
The leaves curled back in elaborate Corinthian scrolls;
And the air cool, as if drifting down from wet hemlocks,
Or rising out of ferns not far from water,
A crisp hyacinthine coolness,
Like that clear autumnal weather of eternity,
The windless perpetual morning above a September cloud.

Theodore Roethke, 'Carnations' (1948)

CHRYSANTHEMUM

Why should this flower delay so long
 To show its tremulous plumes?
Now is the time of plaintive robin-song,
 When flowers are in their tombs.

Through the slow summer, when the sun
 Called to each frond and whorl
That all he could for flowers was being done,
 Why did it not uncurl?

It must have felt that fervid call
 Although it took no heed,
Walking but now, when leaves like corpses fall,
 And saps all retrocede.

Too late its beauty, lonely thing,
 The season's shine is spent,
Nothing remains for it but shivering
 In tempests turbulent.

Had it a reason for delay,
 Dreaming in witlessness
That for a bloom so delicately gay
 Winter would stay its stress?

I talk as if the thing were born
 With sense to work its mind;
Yet it is but one mask of many worn
 By the Great Face behind.

Thomas Hardy, 'The Last Chrysanthemum' (1901)

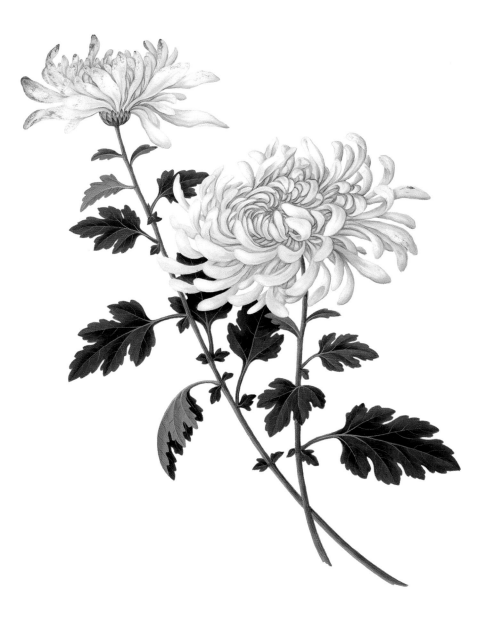

CYCLAMEN

They are terribly white:
There is snow on the ground,
And a moon on the snow at night;
The sky is cut by the winter light;
Yet I, who have all these things in ken,
Am struck to the heart by the chiselled white
Of this handful of cyclamen.

Katherine Harris Bradley and Edith Emma Cooper ('Michael Field'),
'Cyclamens' (1893)

HAREBELL POPPY

And now, immediately, the beauty of the Harebell Poppy began to break upon us. It was everywhere, flickering and dancing in millions upon millions of pale purple butterflies, as far as eye could see, over all the enormous slopes and braes of the grass. The sun was now coming up, and its earliest rays slanted upon the upland in shafts of gold-dust; in the young fresh light the whole alp was a glistering jewel-work with dew in a powdered haze of diamond, with the innumerable soft blue laughter of the Poppies rippling universally above a floor of pale purple Alpine Asters, interspersed with here and there the complacent pinkness of the Welcome Primula. In the far-off memory of that scene I have to rein myself in, for fear a flux of words should ensue: but do not be embittered, all you who incline to be jealous, scornful, or incredulous of lovelinesses you have never shared (and possibly never could) if I tell you coldly that even I, in those moments, was stricken dumb and helpless by the sight of a glory surpassing, as I do truly think, all that I have ever seen elsewhere. Stupid with a blank delight, I wandered spellbound over those unharvested lawns, agonizing with the effort to contain without breaking the infinite flood of glory they were so mercilessly pouring into so frail and finite a vessel. One did not dare speak. It was indeed a pain almost like the water-torture of Madame de Brinvillers. And at my side walked Bill, silent as I. What was he thinking then? How was this sight striking home to him? But who can ever know what even these dearest and nearest are doing and enduring in the secret inmost rooms of the soul? We continued together, voiceless and smitten.

And then at last he turned to me, and in the awe-strioken whisper of one overwhelmed by a divine presence, he said: 'Doesn't it make your very soul ache?' It was the right, the absolute and final word. It did. It twisted one's very being, in the agony to absorb that sight wholly, to get

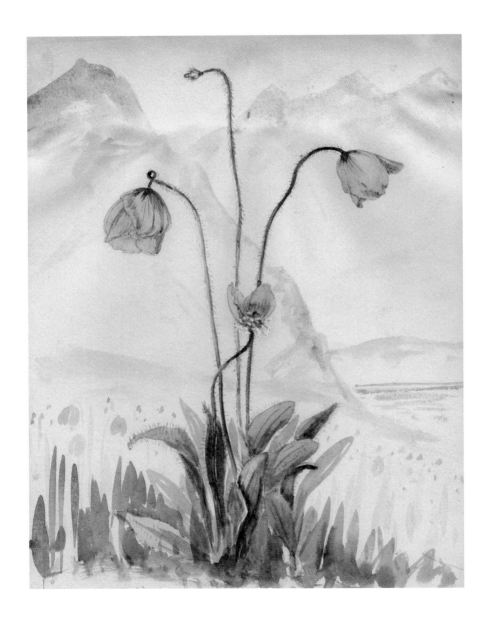

outside it, possess it, delay its passing, tear it away from its native hills and keep it with one for ever – flesh of one's flesh, and brain of one's brain. But beauty is so big and enduring, and we so small and evanescent, that for us the almost physical pain of trying to pack the incommensurable inside the infinitesimal is, indeed, as if one should try to decant the Yellow River into a thimble. Let us hope that even a drop remains inside the poor little vessel round which so titanic an overflow goes inevitably lost, roaring and seething in a spate that would baffle any holding capacity.

Meconopsis quintuplinervia! Will anybody wonder that even I, hating as I do the Wardour Street popular names with which Ruskin tried to 'affubler' such known beauties as Saxifrage and Campanula, should now yield to the same weakness, and try to give my beloved Tibetan Poppy an English name to which she has no right at all? But I hope it is only proleptically that I forge the name of Harebell Poppy. I hope that the plant's beauty and its charm and its permanence will so ensure its popularity in gardens as to make a popular name inevitable. And, that being so, there will be 'Harebell Poppy' ready made. For indeed, to cherish or even to purchase, a plant called *Meconopsis quintuplinervia* is as impossible as to love a woman called Georgiana: mitigating substitutes inevitably have to be invented. So, as the 'Harebell Poppy,' may my Tibetan treasure long enrich our gardens, luxuriant and enduring in rich moist ground, and inimitably lovely in the well-bred grace of its habit, as well as in the serene and tranquil loveliness of its lavender bells. Some there are, indeed, who misprise these, and find them insufficiently 'showy.' Alas, the prevailing fault of *Meconopsis* is not modesty; but it is in modesty that *M. quintuplinervia*, alone of her kind, excels. Not for her the blatant crude enormousness of *M. integrifolia*, the sinister and snaky splendour of *M. punicea*, the hard clear glory of *M. simplicifolia*: her fluttering butterflies aim at a more quiet charm, that only the dull-eyed and deboshed in taste could dream of calling dull.

Reginald Farrer, The Rainbow Bridge *(1921)*

HYACINTH

There are great diversity of these . . . differences on colour and greatnes, and seasons of bearing. The fairest and largest we call ORIENTALL, because they came first out of Turkey and the Eastern countreys, whereof there are some blew, pale and deepe, smelling sweet, and some white, all which flower betimes, and some of the same colours which flower later, amongst which the rarest is the DOWBLE WHITE, and the FLESH colour, and the ASH colour. And after all these come the VIOLET colour polyanthes, single and dowble, the sweet pale WATCHET, called in Italy Januarius, from a gardener's name, and the dowble Sky or Blew, called there Roseus, from the figure like a rose blowne, the Rosemary color.

Sir Thomas Hanmer, Garden Book *(1659)*

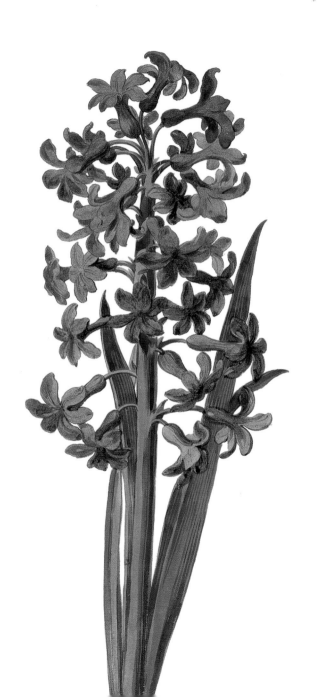

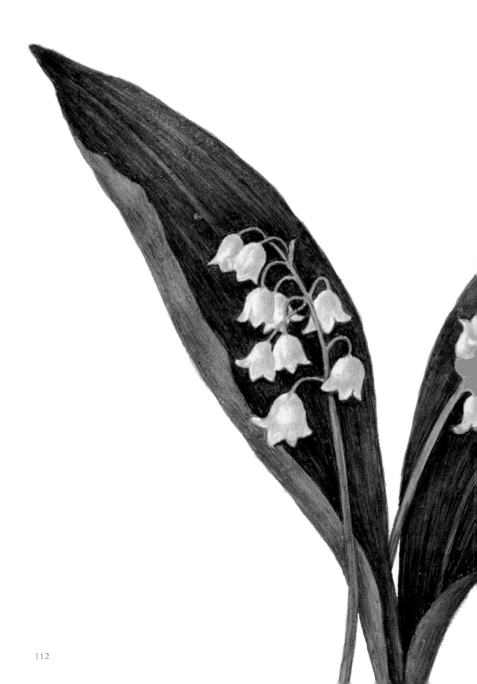

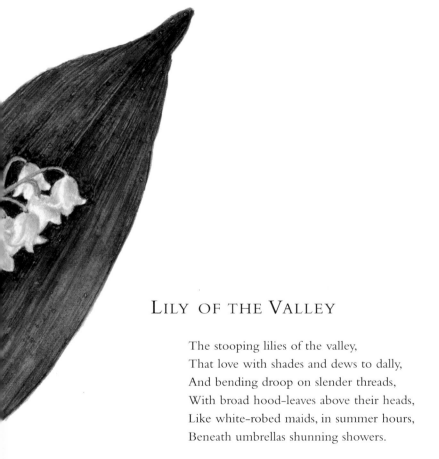

LILY OF THE VALLEY

The stooping lilies of the valley,
That love with shades and dews to dally,
And bending droop on slender threads,
With broad hood-leaves above their heads,
Like white-robed maids, in summer hours,
Beneath umbrellas shunning showers.

John Clare, 'Lilies of the Valley' (1827)

MARIGOLD

Whilst I, the Sunne's *bright Face may view,*
I will no meaner Light *pursue.*

When, with a serious musing, I behold
The gratefull, and obsequious *Marigold*,
How duely, ev'ry morning, she displayes
Her open brest, when *Titan* spreads his Rayes;
How she observes him in his daily walke,
Still bending towards him, her tender stalke;
How, when he downe declines, she droopes and mournes,
Bedew'd (as t'were) with teares, till he returnes;
And, how she vailes her *Flow'rs*, when he is gone,
As if she scorned to be looked on
By an inferior *Eye*; or, did contemne
To wayt upon a meaner *Light*, then *Him*.
When this I meditate, me-thinkes, the *Flowers*
Have *Spirits*, farre more generous, then ours;
And, give us faire Examples, to despise
The servile Fawnings, and Idolatries,
Wherewith, we court these earthly things below,
Which merit not the service we bestow.
 But, oh my God! though groveling I appeare
Upon the Ground, (and have a rooting here,
Which hales me downward) yet in my desire,
To that, which is above mee, I aspire:
And, all my best *Affections* I professe
To *Him*, that is the *Sunne of Righteousnesse.*

Oh! keepe the *Morning* of his *Incarnation*,
The burning *Noon-tide* of his bitter *Passion*,
The *Night* of his *Descending*, and the *Height*
Of his *Ascension*, ever in my sight:
 That imitating him, in what I may,
 I never follow an inferior *Way*.

George Wither, 'The Marigold' (1634)

SNOWDROP

Snowdrops are another herald of the spring. First, they are sort of pale-green points peeping from the soil; then they split into two fat, uterine leaves, and that is that. Then they flower some time at the beginning of February and, I tell you, no Palm of Victory or Tree of Knowledge of Laurel of Glory is more beautiful than this little, white, fragile cup on a pale stalk waving in the rough wind.

Karel Čapek, The Gardener's Year *(1929)*

HIMALAYAN BALSAM

Orchid-lipped, loose-jointed, purplish, indolent flowers,
with a ripe smell of peaches, like a girl's breath through lipstick,
delicate and coarse in the weedlap of late summer rivers,
dishevelled, weak-stemmed, common as brambles, as love which

subtracts us from seasons, their courtships and murders,
(*Meta segmentata* in her web, and the male waiting,
between blossom and violent blossom, meticulous spiders
repeated in gossamer, and the slim males waiting . . .)

Fragrance too rich for keeping, too light to remember,
like grief for the cat's sparrow and the wild gull's
beach-hatched embryo. (She ran from the reaching water
with the broken egg in her hand, but the clamped bill

refused brandy and grubs, a shred too naked and perilous for
life offered freely in cardboard boxes, little windowsill
coffins for bird death, kitten death, squirrel death, summer
repeated and ended in heartbreak, in the sad small funerals.)

Sometimes, shaping bread or scraping potatoes for supper,
I have stood in the kitchen, transfixed by what I'd call love
if love were a whiff, a wanting for no particular lover,
no child, or baby or creature, 'Love, dear love'

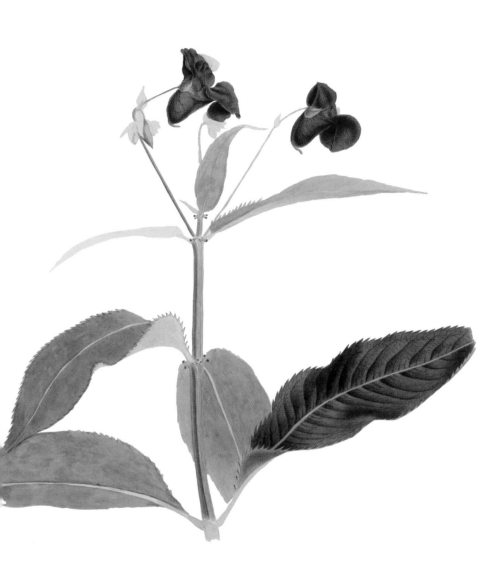

I could cry to these scent-spilling ragged flowers
and mean nothing but 'no', by that word's breadth,
to their evident going, their important descent through red towering
stalks to the riverbed. It's not, as I thought, that death

creates love. More that love knows death. Therefore
tears, therefore poems, therefore the long stone sobs of cathedrals
that speak to no ferret or fox, that prevent no massacre.
(I am combing abundant leaves from these icy shallows.)

Love, it was you who said, 'Murder the killer
we have to call life and we'd be a bare planet under a dead sun
Then I loved you with the usual soft lust of October
that says 'yes' to the coming winter and a summoning odour of balsam.

Anne Stevenson, 'Himalayan Balsam' (1982)

FORGET-ME-NOT

Growing in the earth on top of the ditched wall, and level with my eyes, was the smallest plant of wild forget-me-not I have seen. Scorpion grass, I believe is the proper name, and a lovely name it is; I had to think to remember it from my John's *Flowers of the Field*. The plant could have been covered by a threepenny bit, and its one flower of blue, which returned my gaze so steadily, so serenely, was not much bigger than a pin-point. I wonder what insect it was waiting for, to bring the pollen which would give its seed life. Some strange little winged thing, complete with eyes of a hundred facets or lenses, and wings a thousand times more sensitive and complicated than any aeroplane, with a power unit that no man on earth could copy; or even imagine. That blue flower held all the feeling and hope of the plant which had prepared itself during the winter, clinging to life in frost and withering salt blast, most of its roots washed out of the soil, perhaps torn by the teeth of a rabbit, and spun and twirled with every wind– that blue flower was a manifestation of the plant's hope, of its purpose in life, of Life itself: and to fulfil itself it waited for an almost microscopical insect which, happening to alight on a man's forehead, would be smudged out and instantly forgotten.

Henry Williamson, Goodbye West Country *(1937)*

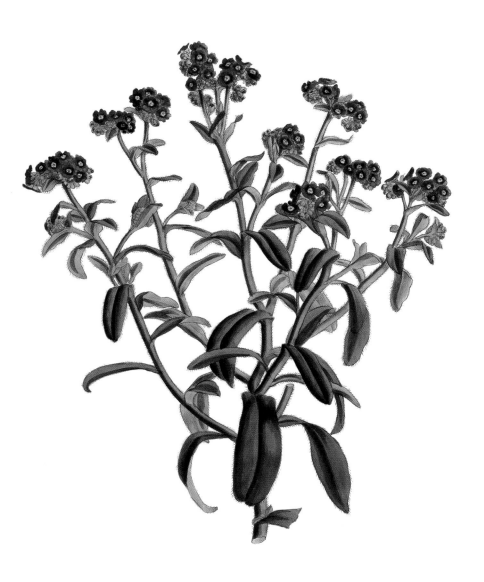

CAMPANULA

The greatest change that I always notice in the rock garden on my return from the hills is the final two feet of growth and bursting into flower of *Campanula lactiflora*, which has become one of our weeds there, and if it were not ruthlessly evicted wherever it is not required would cover the whole place, including the moraines. It was first planted in the triangular flat portion that is now the Dwarf Almond copse, and is Mr. Farrer's delight and envy. I planted three seedlings, all I had, and if any clairvoyant had been crystal-gazing at the moment and told me I should in a few years be digging them up in hundreds to give away and throw away, I should have dug up those three infants, fearing the ruin of my garden. But as I destroy those which, like the abomination of desolation spoken of by the prophet Daniel, stand where they should not, only leaving a row down each side of the path and a few others where they are doing no harm, the rock garden looks exceedingly well during the fortnight of their reign. Nearly all of them at this upper end of the rock garden are either the pure white form, which I think the loveliest of all, or of the skim-milk, bluish-grey tint that provided their specific name, and really blue forms very seldom appear among them. In the lower end, by the *Cotoneaster multiflora*, is another colony, but all of fine blue shades, having sprung from a different ancestor, a fine fellow still alive and hearty, though sent me some dozen or so years ago by Miss Anderson from Barskimming, and is still one of the finest blue forms I have seen. I hope she has many more as good in her lovely Scotch garden, and that she did not send me the best, though I cannot imagine a better form. In some seasons the five to six feet high flower-stems they produce have caused trouble where they grow beside the path by arching over, after a thunderstorm, until they meet in the centre, and the first who ventures to walk through them gets a shower-bath. So now I prepare for such emergencies by nipping off the heads of the stems nearest the path when they are only two or three feet high, which causes them to branch freely, and yet they flower at the same time as their untouched brethren behind, but on shorter stems that do not bend out so far, and have a very

pleasing effect in the forefront. I also nip a few here and there just before I leave for Alpine rambles, and these come into flower a week or more later than the main show, and carry the season on a little. It is marvellous how soon *C. lactiflora* seems to change from lovely flower-heads eighteen inches high by ten through, into clusters of pepper-pots shaking out thousands of minute flattened buff seeds with every jolt and jar. So as soon as the majority of the flowers of a head look a little jaded it is wise to cut off the whole head, or you must prepare for a year or two's extra weeding of seedlings. If cut off close under the lowest flowers, the stems will branch out and flower again later in the season; but it is a poor show that is provided by these small heads of lateral shoots compared with the waving masses of early July.

E.A. Bowles, My Garden in Summer *(1914)*

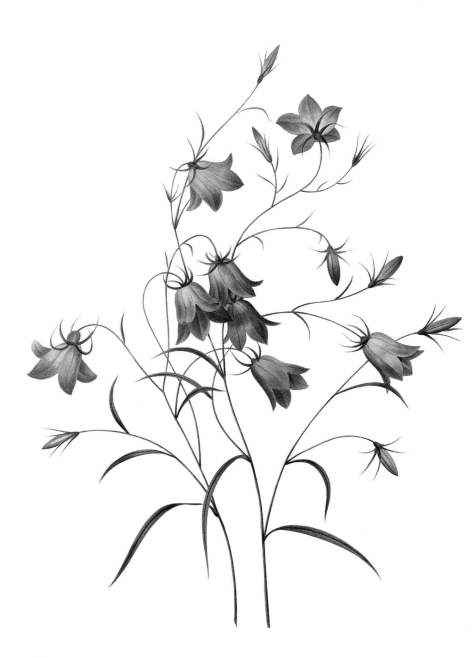

HAREBELL

The harebell is one flower,
Its solitariness
Bespoke by its colour, not blue
Nor violet; hovering between, precisely.
It is a spare delicate bell.
Inside it are three pale sugary stigmas welded
To each other at equal angles,
Not seen until looked for.
Its stem is thin as wire.
The flower looks down, and if
Lifted, looks fixedly
At the admirer.
Its silence halted between primrose and beauty,
Its shape is wrung from the sounds of life round it
As a bell's sound forms the bell's shape from silence,
And resumes its demure integrity;
More precise, more shaped, than the bluebell;
More venturesome. More stirred, ungarrulous.
Stern as a pin.

Jon Silkin, 'Harebell' (1965)

COLCHICUM

Autumn's a preparation for renewal,
Yet not entirely shorn
Of tardy beauty, last and saddest jewel
Bedizening where it may not adorn.
Few of the autumn blooms are deeply dear,
Lacking the spirit volatile and chaste
That blows across the ground when pied appear
The midget sweets of Spring, and in their haste
The vaporous trees break blossom pale and clear,
– Carpet and canopy, together born.

Stalwarts of Autumn lack that quality;
Only the little frightened cyclamen
With leveret ears laid back look fresh and young,
Or those pure chalices that Kentish men
Call Naked Boys, but by a lovelier name
Others call Naked Ladies, slender, bare,
Dressed only in their amethystine flame,
The Meadow Saffron magically sprung
By dawn in morning orchards in the grass
Near paths where shepherds on their errand pass
But ender-night beheld no crocus-colour there.

V. Sackville-West, The Garden *(1946)*

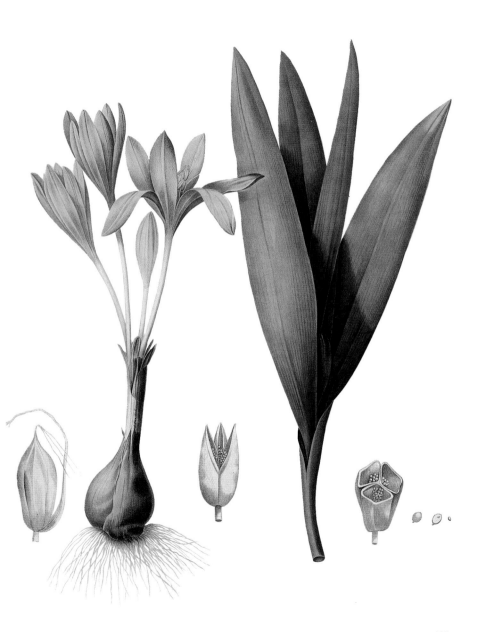

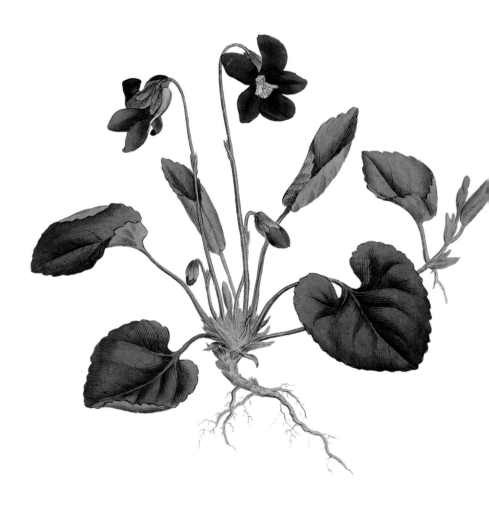

VIOLET

There might be described many kindes of floures under this name of Violets, if their differences should be more curiously looked into than is necessarie: for we might joine hereunto the stock Gillofloures, Wall-floures, Dames Gillofloures, Marian violets, & likewise some of the bulbed floures, because some of them by *Theophrastus* are termed Violets. But this was not our charge, holding it sufficient to distinguish and divide them as neere as may be in kindred and neighbourhood; addressing my selfe unto the Violets called the blacke or purple violets, or March Violets of the garden, which have a great prerogative above others, not only because the mind conceiveth a certain pleasure and recreation by smelling and handling those most odoriferous floures, but also for that very many by these violets receive ornament and comely grace; for there be made of them garlands for the head, nosegaies and poesies, which are delightfull to looke on and pleasant to smel to, speaking nothing of their appropriat vertues; yea gardens themselves receive by these the greatest ornament of all, chiefest beauty, and most excellent grace, and the recreation of the minde which is taken hereby cannot be but very good and honest; for they admonish and stirre up a man to that which is comely and honest; for floures through their beauty, variety of colour, and exquisit forme, do bring to a liberall and gentle manly minde, the remembrance of honestie, comlinesse, and all kindes of vertues: for it would be an unseemly and filthy thing (as a certain wise man saith) for him that doth looke upon and handle faire and beautiful things, to have his mind not faire, but filthy and deformed.

John Gerard, Of the Historie of Plants *(1597)*

BLUEFLAGS

I stopped the car
to let the children down
where the streets end
in the sun
at the marsh edge
and the reeds begin
and there are small houses
facing the reeds
and the blue mist in the distance
with grapevine trellises
with grape clusters
small as strawberries
on the vines
and ditches
running springwater
that continue the gutters
with willows over them.
The reeds begin
like water at a shore
their pointed petals waving
dark green and light.
But blueflags are blossoming
in the reeds
which the children pluck
chattering in the reeds
high over their heads
which they part
with bare arms to appear

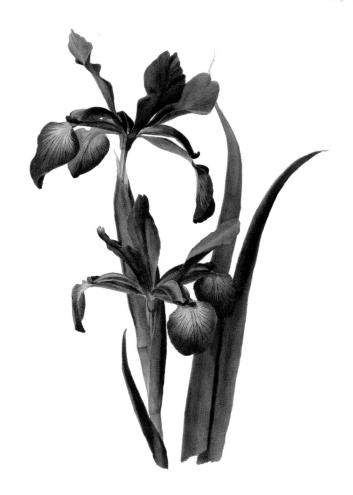

with fists of flowers
till in the air
there comes the smell
of calamus
from wet, gummy stalks.

William Carlos Williams,
'Blueflags' (1921)

DAISY

Wee, modest, crimson–tipped flow'r,
Thou's met me in an evil hour;
For I maun crush amang the stoure
 They slender stem:
To spare thee now is past my pow'r,
 Thou bonie gem.

Alas! it's no thy neebor sweet,
The bonie *Lark*, companion meet!
Bending thee 'mang the dewy weet!
 Wi's spreckl'd breast,
When upward–springing, blythe, to greet
 The purpling East.

Cauld blew the bitter–biting *North*
Upon thy early, humble birth;
Yet chearfully thou glinted forth
 Amid the storm,
Scarce rear'd above the *Parent-earth*
 Thy tender form.

The flaunting *flow'rs* our Gardens yield,
High–shelt'ring woods and wa's maun shield,
But thou, beneath the random bield
 O'clod or stane,
Adorns the histie *stibble-field*,
 Unseen, alane.

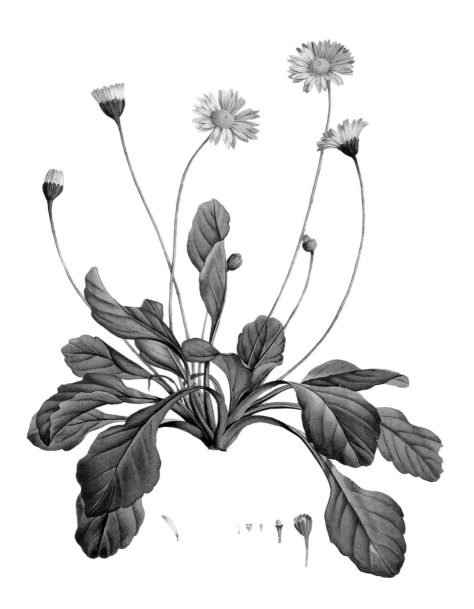

There, in thy scanty mantle clad,
Thy snawie bosom sun-ward spread,
Thou lifts thy unassuming head
 In humble guise;
But now the *share* uptears thy bed,
 And low thou lies!

Such is the fate of artless Maid,
Sweet *flow'ret* of the rural shade!
By Love's simplicity betray'd,
 And guileless trust,
Till she, like thee, all soil'd, is laid
 Low i' the dust.

Such is the fate of simple Bard,
On Life's rough ocean luckless starr'd!
Unskilful he to note the card
 Of *prudent Lore*,
Till billows rage, and gales blow hard,
 And whelm him o'er!

Such fate to *suffering worth* is giv'n,
Who long with wants and woes has striv'n,
By human pride or cunning driv'n
 To Mis'ry's brink,
Till wrench'd of ev'ry stay but Heav'n,
 He, ruin'd, sink!

Ev'n thou who mourn'st the *Daisy's* fate,
That fate is thine – no distant date;
Stern Ruin's *plough-share* drives, elate,
 Full on thy bloom,
Till crush'd beneath the *furrow's* weight,
 Shall be thy doom!

Robert Burns, 'To a Mountain-Daisy' (1786)

INDEX OF FIRST LINES

INDEX OF PLANTS, AUTHORS AND ARTISTS

LIST OF ILLUSTRATIONS

46–7 Sundew (*Drosera rotundifolia*) by Ferdinand Bernhard Vietz, *Icones plantarum medico-oeconomico-technologicarum*, Vol. 6 (1817), Plate 483b.

48 Rhododendron (*Rhododendron ponticum*) by Winnifred Bussey (*c.*1960).

51 Anemone (*Anemone nemorosa* 'Robinsoniana') from *Gartenflora*, Vol. 27 (1878), Plate 945.

52 Primrose (*Primula vulgaris*) by James Sowerby, *English Botany*, Vol. 1 (1791) Plate 4.

55 Erythronium (*Erythronium glandiflorium*) by Miss S.A. Drake, *Botanical Register*, Vol. 21 (1836).

57 Amaranth (*Amaranthus speciosus*) by John Curtis, Curtis's *Botanical Magazine* (1821).

59 Old Man (*Artemisia abrotanum*) by James Sowerby, *William Woodville's Medical Botany* (1792).

60 Alpine Forget-Me-Not (*Eritrichium nanum*) by Walter Hood Fitch, Curtis's *Botanical Magazine* (1870), Plate 5853.

63 Poppy (*Papaver bractaetum*), hand-coloured engraving after a drawing by John Lindley, *Collectanea botanica* (1821), Plate 23.

64 • Fuchsia (*Fuchsia magellanica*) by Pierre-Joseph Redouté, *Traité Des Arbres et Arbustes*, Vol. 1 (*c.*1801), Plate 13.

67 Geranium (*Pelargonium inquinans*) by Pancrace Bessa, *Traité Des Arbres et Arbustes*, Vol. 7 (1825), Plate 20.

68 Columbine (*Aquilegia vulgaris* var. 'Flore pheno') by John Edwards, *Edwards' Herbal* (1770).

71 Jasmine (*Jasminum*) by Giovanni Geri, *Raccolta di Fiori Frutti ed Agrumi* (1825), Plate 12.

72 Snakeshead Fritillary (*Fritillaria meleagris*) by Ferdinand Bernhard Vietz, *Icones plantarum medico-oeconomico-technologicarum*, Vol. 6 (1817), Plate 521.

75 *Lilium regale* by Lilian Snelling, *Supplement to Elwes' Monograph of the Genus Lilium* (1936), Plate 9.

76 Pansy (*Viola tricolor* and cultivars) by Jane W. Loudon, *Ladies' Flower-Garden of Ornamental Annuals* (1840), Plate 14.

79 Sunflower (*Helianthus annuus*) by Pierre-Joseph Buchoz, *Collection Precieuse et Enlumineé des Fleurs,* Part 2 (1776), Plate 12.

81 Rose (*Rosa moyesii*) by Alfred Parsons, *The Genus Rosa*, Vol.1 Part 2 (1914).

82 Greater Burnet Saxifrage (*Pimpinella major*) by Ignatz Alberti, *Icones Plantarum* (1817).

85 Lent Lily (*Narcissus pseudonarcissus*) by Dorothy Burt Martin (*c.*1930).

86 Woodspurge (*Euphorbia amygdaloides*) by Dorothy Burt Martin (*c.*1930).

89 Peony (*Paeonia*) by Heinrich Witte, *Flora* (1868), Plate 46.

91,93 Celandine (*Chelidonium*) by Pierre Jean François Turpin (1775–1840).

95 Bird's Foot Trefoil (*Lotus corniculatus*) by James Sowerby, *English Botany*, Vol. 30 (1810), Plate 209.

96 Lily (*Lilium candidum*) from Curtis's *Botanical Magazine*, Vol.8 (1794), Plate 278.

99 Broom (*Cytisus scoparius*) by Dorothy Burt Martin (*c*.1930).

101 Plumbago (*Plumbago capensis*) by John Curtis, Curtis's *Botanical Magazine* (1820), Plate 2110.

102 Carnation (*Dianthus caryophyllus*) by Frans Georg Beissner (1681), Plate 129.

105 Chrysanthemum (*Chrysanthemum indicum* 'Tasselled White', Chinese artist commissioned by John Reeves for the RHS (1805–20).

106 Cyclamen (*Cyclamen coum* 'Album') by Pierre de Savary (1762–75).

108 Harebell Poppy (*Meconopsis quintuplinervia*) by Reginald Farrer (1914).

111 Hyacinth (*Hyacinthus*) by Pieter Holsteyn (*c*.1614—73)

112–13 Lily of the Valley (*Convallaria majalis*) by Christina Maria Applebee (1814).

115 Marigold (*Calendula officinalis*) by Ferdinand Bernhard Vietz, *Icones plantarum medico-oeconomico-technologicarum*, Vol. 1 (1800), Plate 36.

116 Snowdrop (*Galanthus nivalis*) by John Paul Wellington Furse (1959).

118 Himalayan Balsam (*Impatiens glandulifera*) by Charles James Fox Bunbury (1842).

121 Forget-Me-Not (*Myosotis azorica*) by Louis Aristide Léon Constans, *Paxton's Flower Garden* Vol. 3 (1850–3) Plate 97.

123 *Campanula lactiflora* from Curtis's *Botanical Magazine* (1818) Plate 1973.

124 Harebell (*Campanula rotundifolia*) by Pierre-Joseph Redouté, *Choix des Plus Belles Fleurs* (1827), Plate 20.

127 Colchicum (*Colchicum autumnale*) by Pierre-Joseph Redouté, *Les Liliacées*, Vol. 4 (1802–16), Plate 228.

128 Violet (*Viola odorata*) by James Sowerby, *William Woodville's Medical Botany*, Vol 2. (1792), Plate 81.

131 Blueflags (*Iris monspur*) by Miss Williamson (1905).

133 Daisy (*Bellis perennis*) by Pancrace Bessa (1772–1846).

144 *Tulipa* 'La Belle' attributed to August Wilhelm Sievert, *Hortus florum imaginum* (*c*.1730) Plate 18.

ACKNOWLEDGMENTS

The publishers would like to thank Emma Reuss (RHS Books) and Charlotte Brooks and Annika Browne (RHS Lindley Library) for their help with this book.

Extracts from *My Garden in Summer* by E.A. Bowles (David & Charles, 1972) by kind permission of the publishers; extract from *A Flower for Every Day* by Margery Fish reproduced by permsission of Anover Books Company Ltd; extract from *The Essential Earthman* by Henry Mitchell reproduced by permission of Indiana University Press; 'Rosemary' and 'Roses Only' from *The Poems of Marianne Moore* by Marianne Moore, edited by Grace Schulman, copyright © 2003 by Marianne Craig Moore, Executor of the Estate of Marianne Moore. Used by permission of Viking Penguin, a division of Penguin Group (USA) Inc. and by permission of Faber and Faber Ltd; 'Morning Glory' by Ruth Pitter, from *Collected Poems* (Enitharmon Press, 1986) reproduced by permission of Enitharmon Press; 'Snakeshead Fritillaries' by Anne Ridler, from *Collected Poems* (Carcanet, 1994) reproduced by permission of Carcanet Press Ltd; 'Carnations' and 'Orchids' by Theodore Roethke reproduced by permission of Faber and Faber Ltd; extract from *The Scented Garden* by Eleanour Sinclair Rohde reproduced by kind permission of The Medici Society Ltd/The Estate of Eleanour Sinclair Rohde; extracts from *Even More for Your Garden* and *The Garden* copyright © Vita Sackville-West 1946, reproduced with permission of Curtis Brown Group Ltd on behalf of the estate of Vita Sackville-West; 'Himalayan Balsam' by Anne Stevenson, from *Poems 1955–2005* (Bloodaxe, 2005), reproduced by permission of Bloodaxe Books; 'Blue Flags' and 'Queen Anne's Lace' by William Carlos Williams, from *Collected Poems Volume 1* (Carcanet, 1988) reproduced by permission of Carcanet Press Ltd.

The publishers apologise to any copyright holders that they were not able to trace and would like to hear from them.

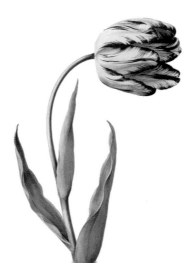